THE YUKON

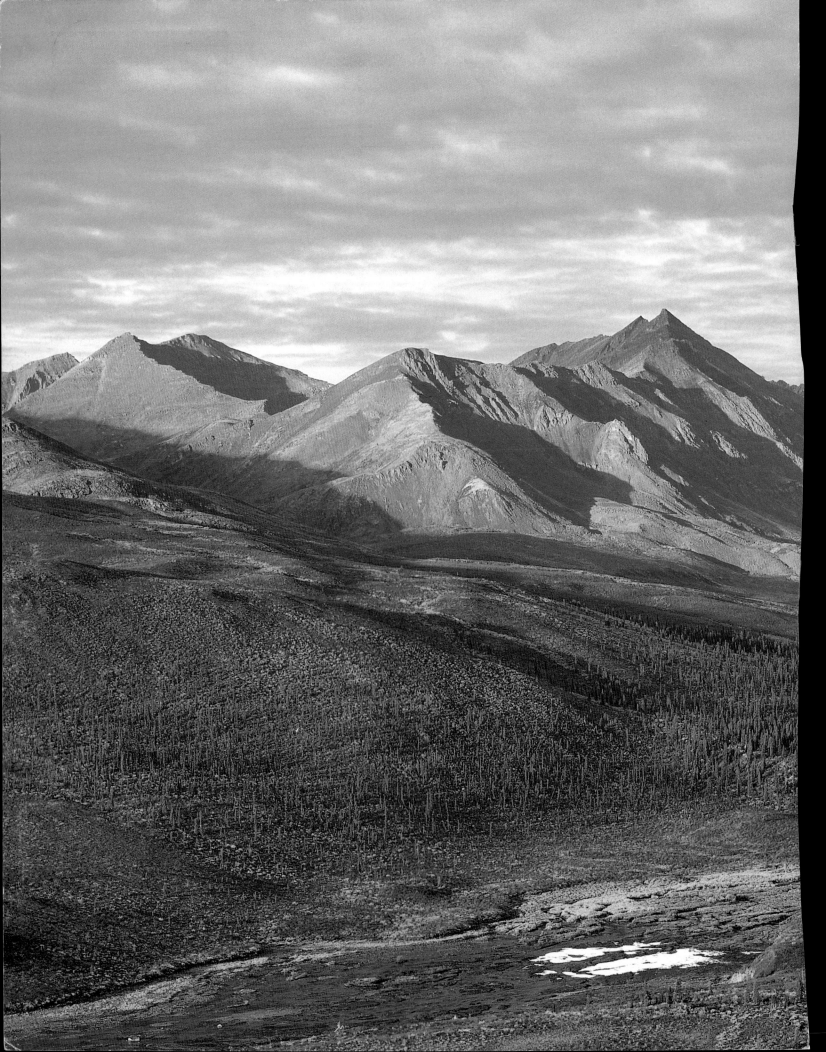

THE YUKON

PAT & BAIBA MORROW

FIREFLY BOOKS

A FIREFLY BOOK

Cataloguing-in-Publication Data

Morrow, Pat, 1953–
 The Yukon

ISBN 1-55209-108-2

1. Yukon Territory – Pictorial works.
I. Morrow, Baiba. II. Title.

FC4012.M68 1997 917.19 ' 1 ' 00222 C97-930873-9
F1091.M68 1997

Published by
Firefly Books Ltd.
3680 Victoria Park Avenue
Willowdale, Ontario
Canada M2H 3K1

Published in the U.S. by
Firefly Books (U.S.) Inc.
P.O. Box 1338, Ellicott Station
Buffalo, New York 14205

Produced by
Bookmakers Press Inc.
12 Pine Street
Kingston, Ontario K7K 1W1

Design by
Linda J. Menyes
Q Kumquat Designs

Color separations by
Friesens
Altona, Manitoba

Printed and bound in Canada by
Friesens
Altona, Manitoba

Printed on acid-free paper

WINDOW OF ST. ANDREW'S ANGLICAN
CHURCH, FORT SELKIRK

Many people were instrumental in helping us both before and during the photographic shooting for this book. The list below is by no means complete, and we would like to take this opportunity to thank *everyone* who had a part in it.

Hector and Anne MacKenzie, Yukon
 Mountain and River Expeditions
Robin Armour, Photography Supervisor,
 Yukon Territorial Government
Jim Kemshead, Tourism Yukon
Neil Hartling, Nahanni River Adventures
Ken Spotswood
Pat and Mary Egan
Mark and Marty Ritchie
Brent Liddle
Myk and Uschi Kurth
Ron Chambers, Kruda Ché
 (Tutchone for "otter")
Andrew Lawrence and Rosemary Buck
Al Kapty, Adam Morrisson and Doug

Makkonen, Trans North Helicopters
Juri Peepre, Canadian Parks and
 Wilderness Society
Marten Berkman
Norman Barichello
Ken Madsen
Wayne, Sandy, Bob and Lynch Curry
Martyn Williams
Torrie Hunter
Chris Guenther
Derek Endress, Cloudberry Adventures
Jill Pangman and Joyce Majiski,
 Sila Sojourns/Ecosummer Yukon
Gary Parker and Larry Vezina, Klondike
 Visitors Association
Neil Stephenson and Marcel Marth,
 Canon
Peter Kruka, Agfa
Bob Smythe and Michael Mayzel,
 Daymen Photo Marketing
Richard Gulland, Blackwater Designs
Sandro Parisotto, Scarpa

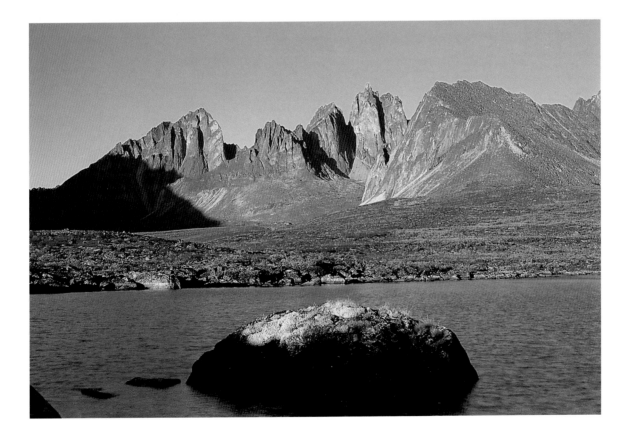

MOUNT MONOLITH MASSIF AND UNNAMED TARN

THE AUTHORS

BAIBA AND PAT MORROW

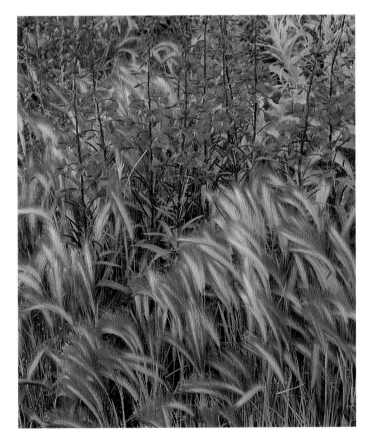

FIREWEED, THE YUKON'S TERRITORIAL FLOWER, WITH FOXTAIL BARLEY GRASS

I t isn't often that job requirements include the skills of first-class photographers, writers, mountaineers and skiers, but that is exactly what is demanded of Pat and Baiba Morrow, Canada's premier adventure photojournalists. The pair has shared the logistical planning of assignment work and expeditions to all seven continents, recording their experiences in photographs, words, film and video.

Pat's career in the public spotlight was launched in 1982, when he climbed Mount Everest. After that, he undertook a global climbing project in which his goal was to become the first person to reach the summit of the highest mountain on all seven continents. That successful venture was documented in his book, *Beyond Everest: Quest for the Seven Summits*, and in 1987, Pat was named to the Order of Canada in recognition of his achievement.

These days, the Morrows make at least one major trip a year, using their climbing and outdoor wilderness skills to photograph the smoking volcanoes of Kamchatka, an 80-day trek across the Himalayas in Nepal or a traverse of the Japan Alps. Their plans for 1997/1998 include a yak-supported crossing of the remote Chang Tang Plateau in Tibet with American biologist George Schaller, an expedition to Sikkim in the eastern Himalayas and a traverse of South Georgia Island in the sub-Antarctic. Their home in the Rocky Mountains on the edge of Banff National Park serves as an inspirational base between expeditions.

Pat's first book was produced in the Yukon in 1978, and since then, both he and Baiba have returned many times on photographic assignments to the far reaches of the territory. The photographs in *The Yukon* were taken during these trips, the most recent of which was a three-month foray to the territory in the summer of 1996.

CONTENTS

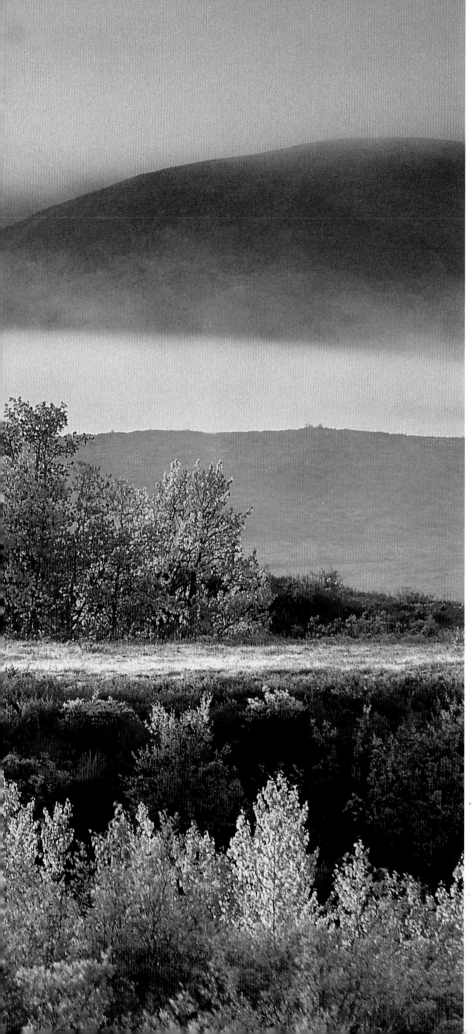

FALL COLORS ALONG THE
DEMPSTER HIGHWAY

INTRODUCTION

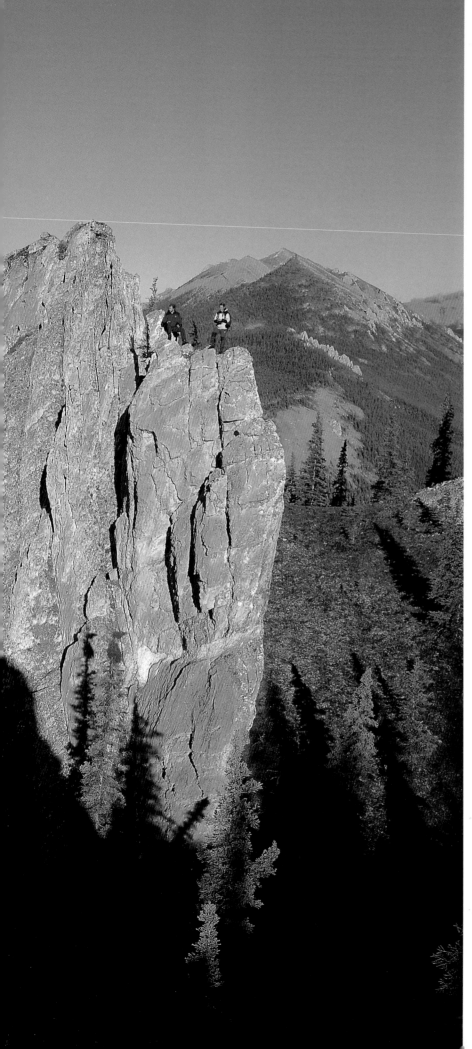

The Yukon takes its name from *Yu-kun-ah*, the Loucheux word for the Yukon River, the "great river" that drains most of the territory. Some 5 percent of Canada's landmass, the Yukon lies in the northwest corner of Canada. Bordered on three sides by rugged mountains and on the fourth by the Arctic Ocean, it shares many of the characteristics of its neighbors, Alaska, British Columbia and the Northwest Territories. It is a land rich in natural wonders—rugged mountain peaks, deep canyons, raging rivers, meadowlands strewn with wildflowers—a landscape whose wildest aspects are available only to the hiker, the climber and the paddler.

Only a hundred years ago, under the able stewardship of the First Nations peoples, the untrammeled 186,000-square-mile region was as close to a true northern Eden as you could get. And despite the tremendous rewards still available to recreationists and tourists who come from around the world to "mine" this golden storehouse of natural-history treasures, the Yukon's *raison d'être* is inevitably associated with one event, an event that changed the history of this huge parcel of pristine wilderness.

EXPLORING THE DOLOMITE CLIFFS OF SAPPER HILL, NORTHERN OGILVIE RANGE

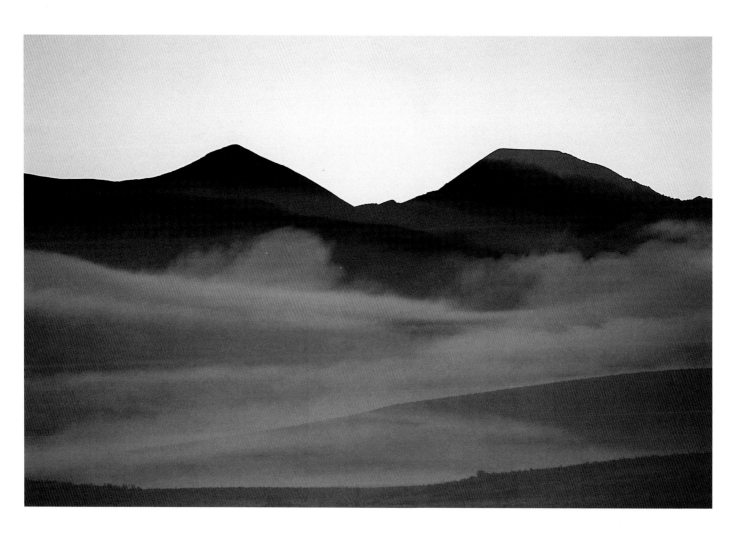

AUTUMN FOG, BLACKSTONE UPLANDS

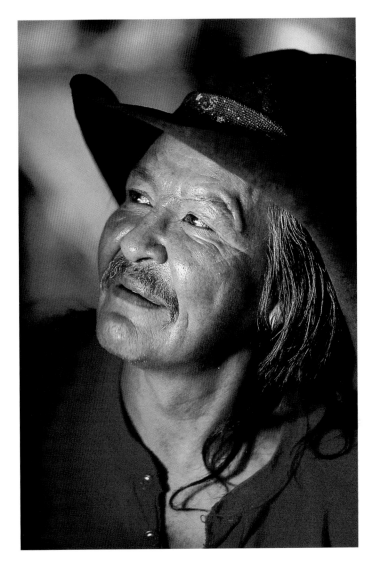

On August 17, 1896, George Carmack, Dawson Charley and Skookum Jim Mason stumbled upon placer gold gleaming in the bed of the Yukon's Bonanza Creek. The trio's find marked the beginning of the Klondike Gold Rush, considered the world's last great gold rush, after the Californian, Australian and South African strikes earlier in the century. News of the discovery spread like wildfire. Over the next two years, 100,000 gold-hungry southerners poured into the Yukon via several routes, mainly over Chilkoot Pass from Skagway, Alaska. From there, they made their way on homemade rafts and boats some 450 miles to Dawson City along the principal water route, the Yukon River. For those who could afford it, paddle-wheelers offered passage up the river from its mouth near St. Michael, Alaska. Among the travelers were miners, merchants, adventure seekers, swindlers and thieves. A small but effective force of North-West Mounted Police also swept in to tend to those suffering from the fever.

Between 1897 and 1904, more than $100 million in gold—equivalent to more than a billion dollars by today's standards—was recovered from creeks with names like Bonanza, Eldorado and Gold Bottom. Overnight, the moose bog chosen for Dawson's site was filled in with tailings from nearby placer workings. At the rush's peak, 30,000 citizens crammed Dawson's muddy streets, making it the largest Canadian city west of Winnipeg. Canada's federal government declared the Yukon a separate territory on June 13, 1898, and Dawson was named its capital.

Ironically, by the time the majority of gold seekers arrived that summer, the best ground had already been staked. Those who could took jobs working others' claims, some of which are still producing today. The rest languished through another Yukon winter before being drawn back down the great river by news of a strike at Nome. Within a couple of years, the flood of humanity had subsided, and the native people, white trappers and Hudson's Bay Company traders who pre-dated the rush were left once again with the tranquillity of nature.

The pace of Yukon life resumed its natural rhythm until the outbreak of World War II. As fear of invasion from Asia approached its zenith, the Alaska Highway and the Canol Road were hastily built through the combined efforts of the U.S. Army Corps of Engineers and Canadian and American civilian contractors. Road construction brought with it a second influx of people. Wilderness was bulldozed, eight mountain ranges were traversed, and the Yukon's isolation, psychological and physical, was ended. In the years after the war, as the dirt road was improved, the territory was flung open to the "outside." Despite this new access, only a trickle of urban refugees followed the road north. In 1953, the Yukon's capital was transferred from Dawson City to Whitehorse, and the Klondike Highway linked the two towns, eliminating paddle-wheeler traffic on the Yukon River.

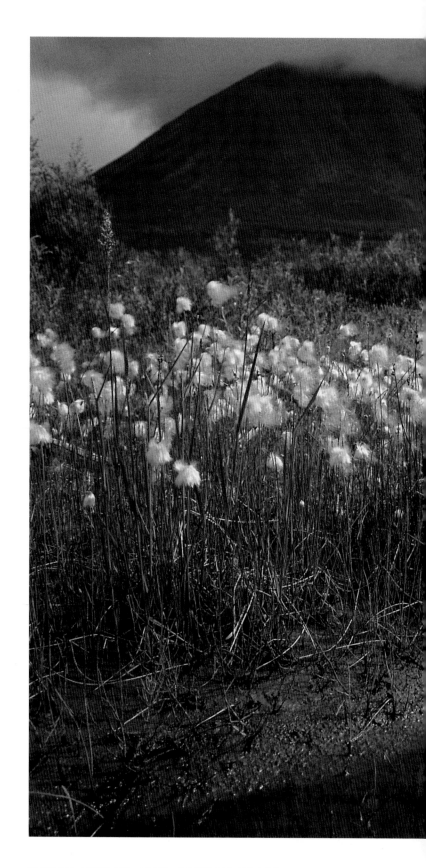

MOOSE ANTLER AMID COTTON GRASS
ALONG THE SNAKE RIVER

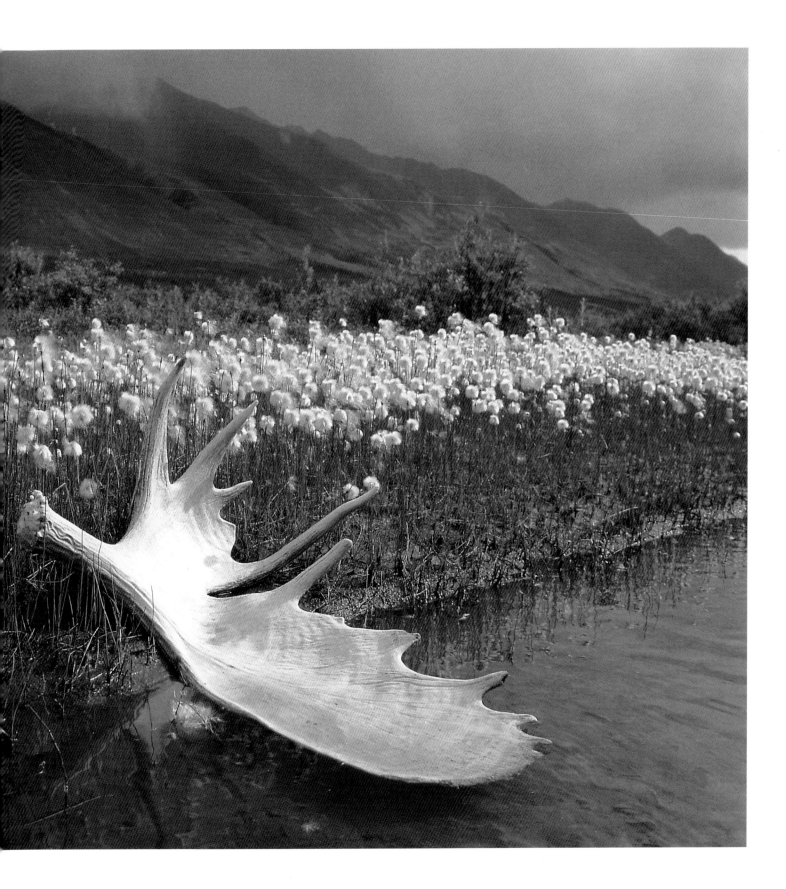

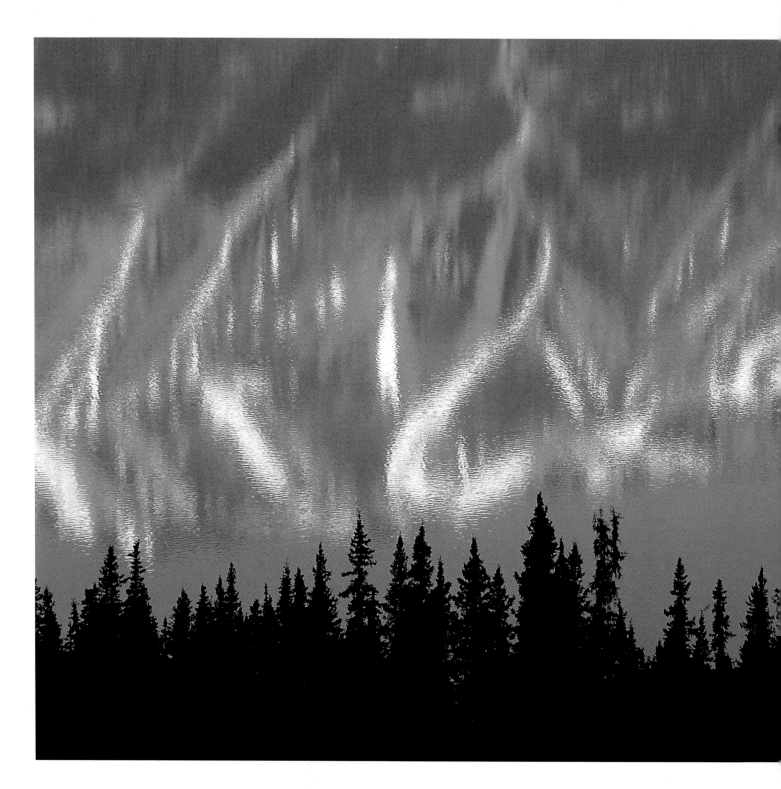

REFLECTION OF ATLIN MOUNTAIN
IN ATLIN LAKE

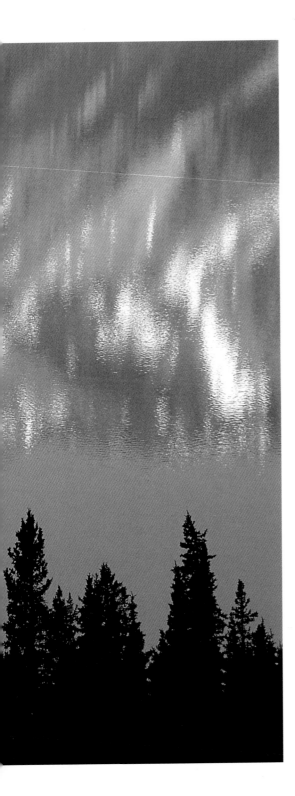

Today when we think of the Yukon, the images that spring to mind are of the Klondike Gold Rush: frostbitten stampeders swarming over Chilkoot Pass through 1897 and 1898; Sam Steele stationed at the snowy summit, dressed in the emblematic red tunic of the North-West Mounted Police, stalwartly upholding the laws of the land; sourdough miners throwing away their hard-earned fortunes at Diamond Tooth Gertie's poker tables in Dawson as high-stepping dance-hall girls prance across the stage.

Is this palette of romantic frontier images due in part to the "promised land" mythology that gushes from the pages of books like Jack London's *The Call of the Wild* and poems like Robert Service's "The Shooting of Dan McGrew"? Service extols more fundamental qualities of this wild northern land in "The Spell of the Yukon":

> *It's the great, big, broad land 'way up*
> *yonder,*
> *It's the forests where silence has lease;*
> *It's the beauty that thrills me with wonder,*
> *It's the stillness that fills me with peace.*

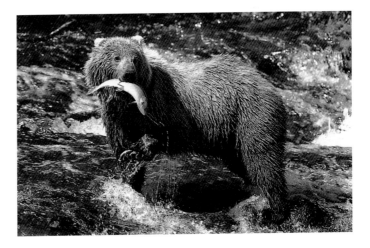

ADULT BROWN BEAR FISHING

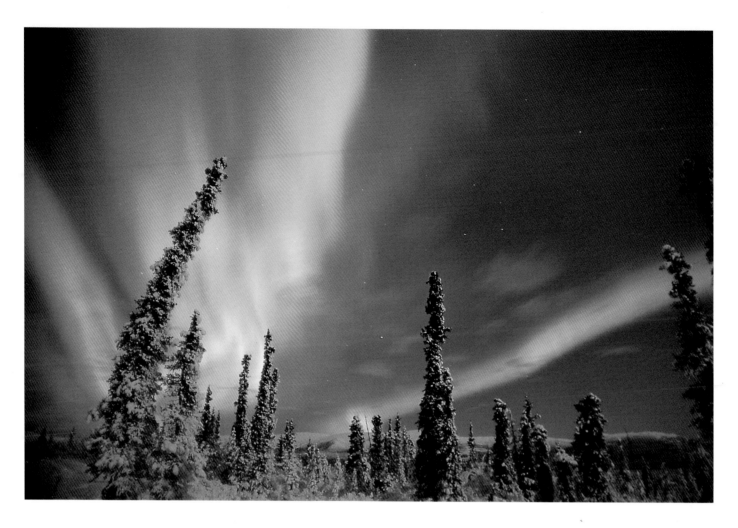

THE NORTHERN LIGHTS

PHOTOGRAPH (ABOVE) BY PHIL HOFFMAN

These chroniclers celebrate not only the burning universal need to pursue adventure for adventure's sake but also the Yukon's pristine primordial appeal. But in our experience, there's more to this northern land than its vivid frontier history and even its superb environment. For us, the people who live there are an essential part of its appeal.

It seems that nearly every Yukoner we've encountered has his or her own colorful story to tell. And if it happens that we first come across these folks in some remote location where they live or recreate, there's a good chance we'll bump into them again on Main Street in Whitehorse or in Dawson, nursing a beer at the Downtown Hotel or at "the Pit," in the Westminster Hotel. Or at Gertie's, if they're feeling lucky.

Since the gold rush, the number of permanent residents in this northern territory hasn't gone much beyond 30,000, perhaps because of the severity of the long winters and the region's relative isolation. But its modest population has kept the Yukon very much a "people-friendly" place where you can drop in unexpectedly on past or new acquaintances and enjoy true northern hospitality. In the smaller communities, kids still leave their bicycles unattended in the streets, and many people don't even have locks on their doors.

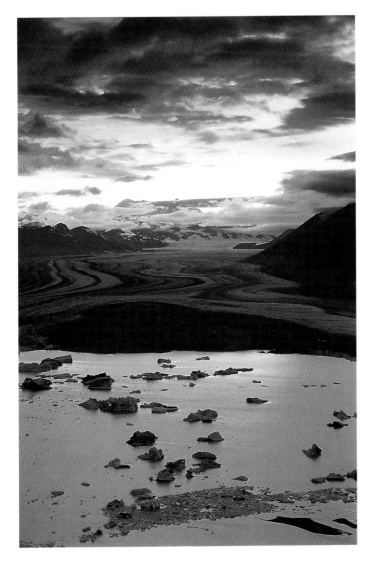

ICEBERGS ON LOWELL LAKE

When Pat first traveled to the Yukon on a family vacation in the late 1960s and again when he returned to shoot his first pictorial book in the late 1970s, simply getting there was an expedition in itself. At that time, only a mile or so of the 1,200 miles of the Alaska "Highway" —from its starting point at Dawson Creek, British Columbia, to where it continues into Alaska near Beaver Creek, Yukon Territory—was paved. Today, that ratio is reversed, and all manner of transport and recreational vehicles speed northward on it.

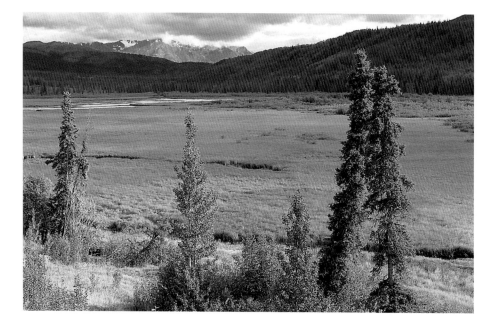

THE ST. ELIAS MOUNTAINS FROM THE HAINES HIGHWAY

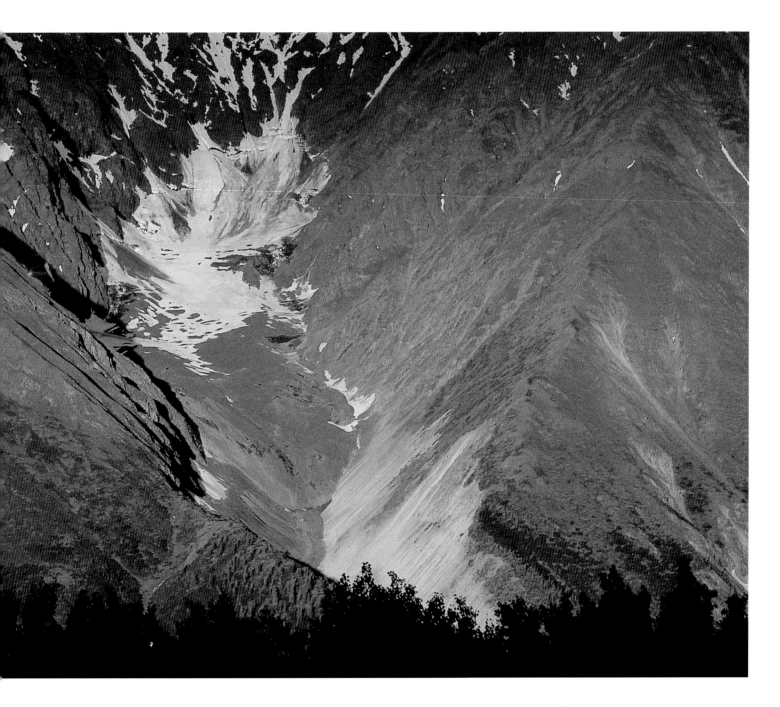

SUNRISE ON THE FRONT RANGES OF
THE ST. ELIAS MOUNTAINS

The current matrix of nearly 3,000 miles of roads provides easy access to many wilderness areas. As once un-spoiled areas in the south fall victim to logging, mining and other commercial interests, not the least of which is being "loved to death" by too many visitors, the intrinsic value of the Yukon's wild places increases. Amazingly, the overall integrity of the landscape has been preserved. As a result of the cooperative efforts of vigilant nature-conservation groups, the federal and territorial govern-ments and the land claims of indigenous peoples who have a vested cultural interest in the land, several national parks have been created and expansions of this system are ongoing.

In compiling the photographs for this book, we have drawn from a stock of material collected over 15 years of inter-mittent visits and an intensive three-month foray in the summer of 1996. *The Yukon* is intended as a celebration of the territory's centennial. While the material does not exhaustively picture its every corner, we've done our best to share the visual excitement we've had in discovering and rediscovering special people and places during our Yukon travels.

We urge you, too, to go out and make some human and geographical discover-ies of your own. And to tread lightly on the land so that generations to come may likewise enjoy it in its natural state.

—Pat and Baiba Morrow

THE SUMMIT OF MOUNT LOGAN,
CANADA'S HIGHEST PEAK

22

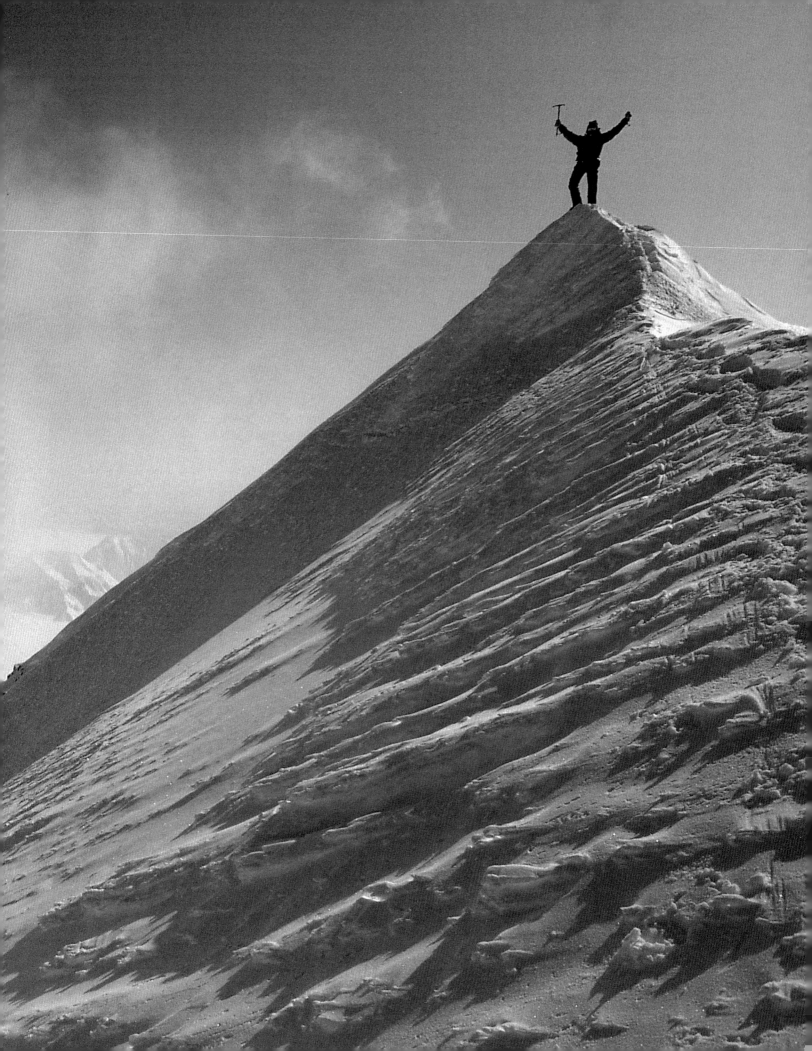

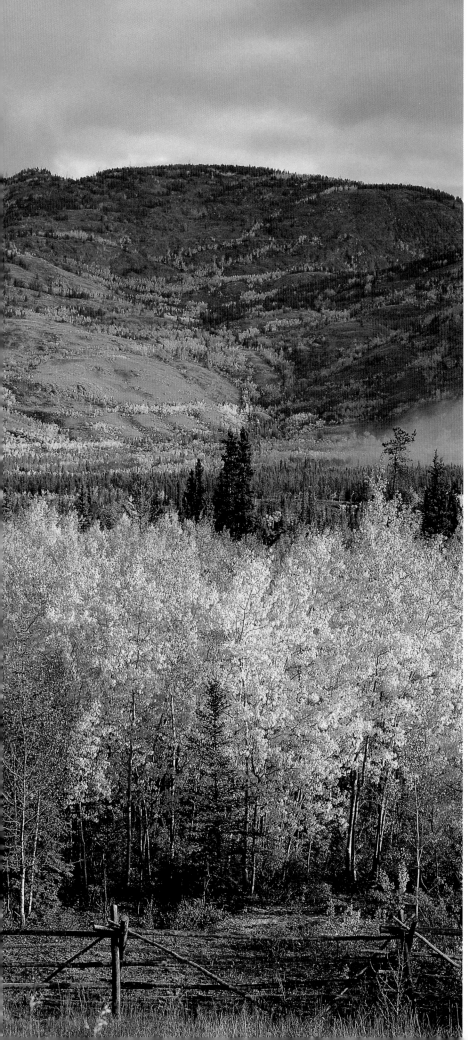

The Yukon's southern region is a labyrinth of lakes and waterways crisscrossed by roads leading to rustic settings like the Circle D Ranch on the Alaska Highway. Located at the area's hub, Whitehorse bustles with the importance of a capital city that offers all the amenities. With roughly 75 percent of the territory's total human population of 32,000 concentrated there, vast tracts of land, uninhabited except for about 50,000 moose, remain to be explored. The Alaska, Klondike and Haines highways—more like quiet country roads than highways—act as conduits to high adventure.

FROM THE ALASKA HIGHWAY
NEAR WHITEHORSE

THE ALASKA HIGHWAY NEAR
THE BRITISH COLUMBIA BORDER

With settlements and people few and far between, the family-run gas stations and cafés along the roads provide vital services. One such haven is Braeburn Lodge, 55 miles north of Whitehorse on the North Klondike Highway. Its gregarious owner Steve Watson (right, bottom) will fill you in on local gossip while serving you the biggest cinnamon bun in the territory. Dedicated to a simple, wholesome lifestyle, Yukon-born artist Sheila Alexandrovich (right, top) lives with her two sons and the family's huskies, goats and turkeys in a remote area 40 miles south of Whitehorse. The Alaska Highway (above) crosses from British Columbia into the Yukon near Watson Lake.

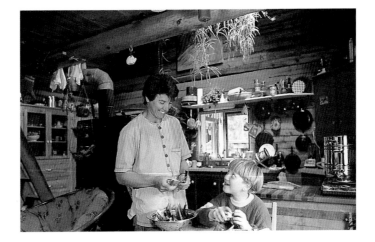

SHEILA ALEXANDROVICH AND SON LEVON

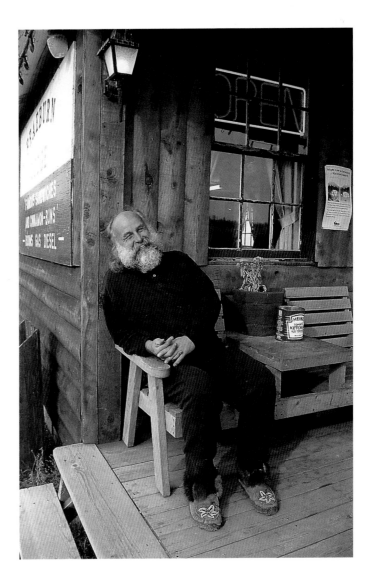

STEVE WATSON, OWNER OF BRAEBURN LODGE

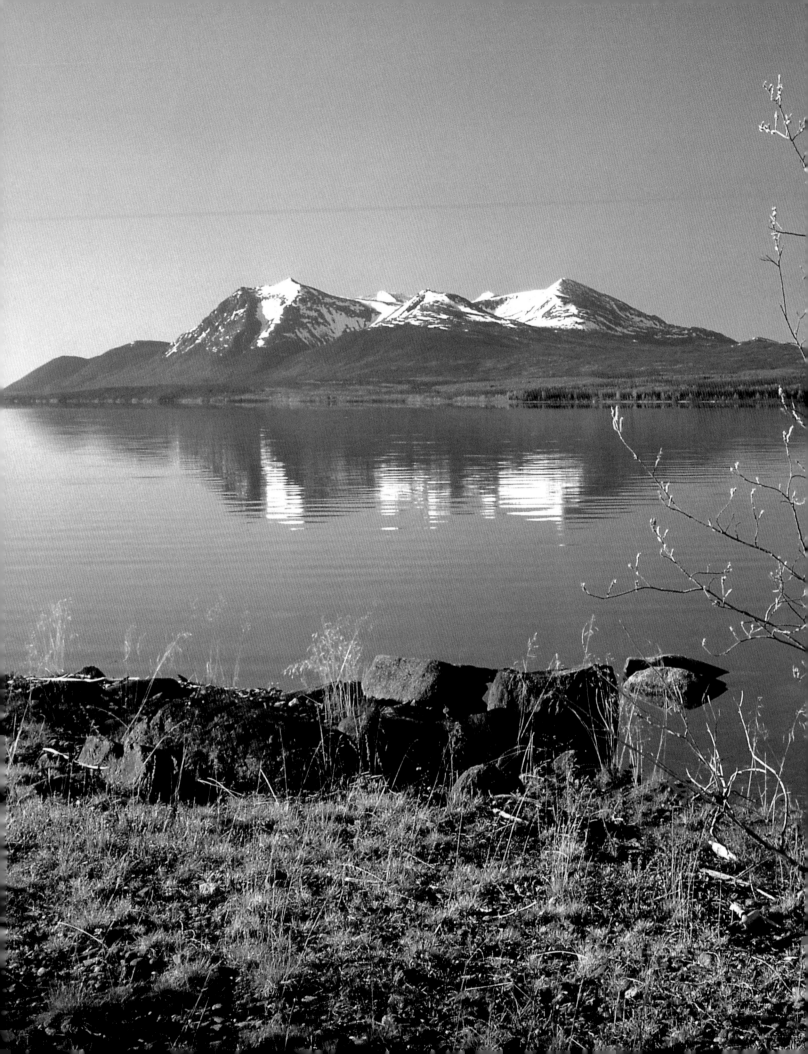

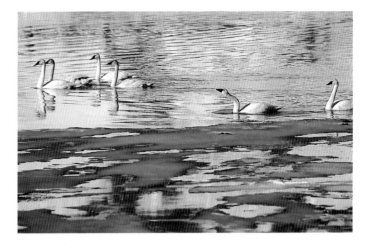

TRUMPETER SWANS ON THE YUKON
RIVER NEAR MARSH LAKE

Southern Yukon lakes such as Teslin (left), Marsh and Laberge are important stopovers for waterfowl waiting for smaller waterways to melt before moving on to their nesting sites. The greatest diversity of birds north of the 60th parallel is found in the southwest corner of the Yukon. The cacophonous honking of trumpeter swans (above), the largest waterfowl in North America, heralds the coming of spring.

DAWSON PEAKS BESIDE
TESLIN LAKE, MID-JUNE

Historically, Dezadeash Lake (below) has played an important role in the lives of First Nations peoples. The Tutchone and Tlingit set up their fishing camps on the shores of this large shallow lake where lake trout, whitefish, northern pike and arctic grayling were abundant. Today, many Yukon people still rely on fishing as a way of life, and the annual chinook, chum and sockeye salmon runs are important events. Gigantic chinook salmon (right, top) swim 2,000 miles up the Yukon River to spawn in the gravel beds of the Teslin River, where the Tlingit net the fish (right, bottom) and smoke them for winter use.

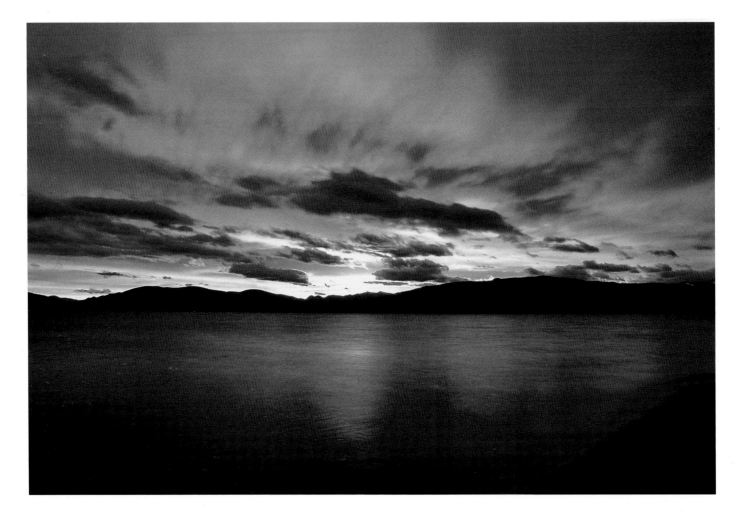

SUNRISE ON DEZADEASH LAKE

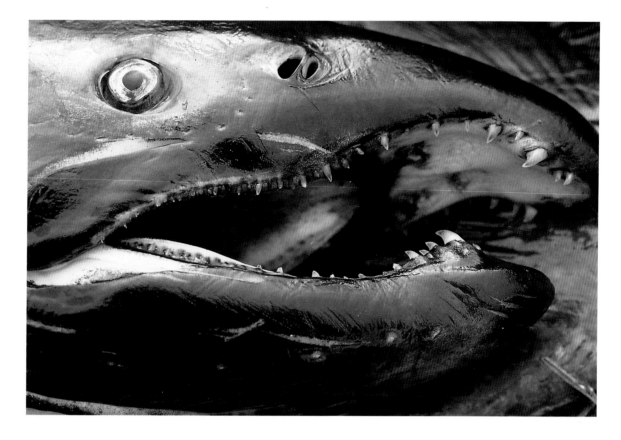

CHINOOK SALMON

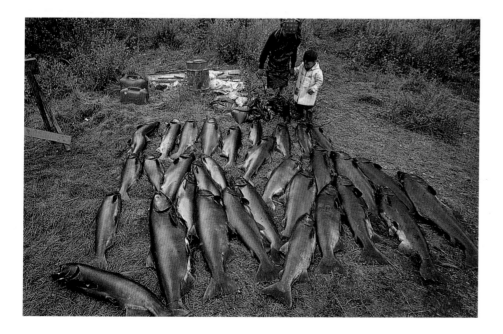

CHINOOK SALMON

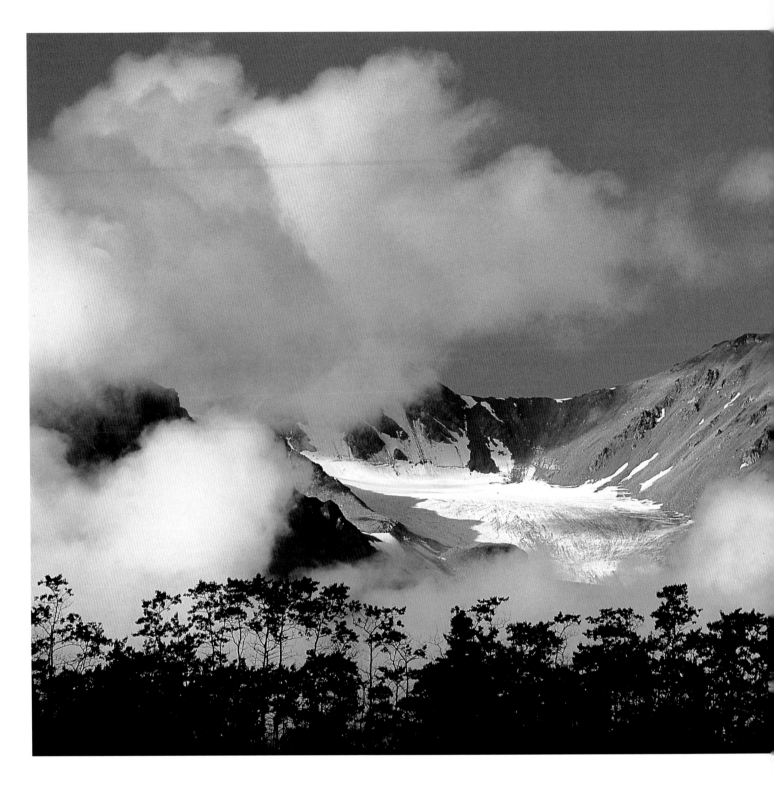

THE ST. ELIAS MOUNTAINS FROM
THE HAINES HIGHWAY

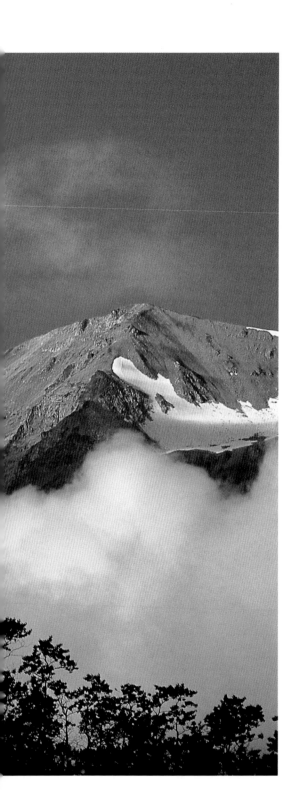

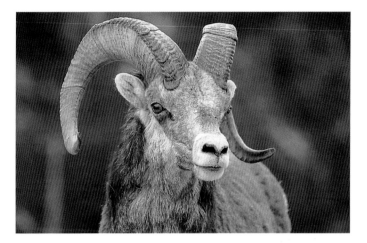

STONE'S SHEEP

Following the traditional trading route of the Tutchone and Tlingit, Oklahoma cowboy Jack Dalton established an alternate route to the Dawson gold fields in 1896. Big enough for horses, cattle and sheep, it became known as the Dalton Trail. Today, the Haines Highway passes along the same spectacular route through the Coast Mountains (left), joining Haines Junction with Haines, Alaska. Wild inhabitants still outnumber by far the human kind in the Yukon, and they often feed along the sides of the roads. Thinhorn Stone's sheep (above), as well as the pure white Dall's, are highly visible from the Alaska Highway.

Carcross entrepreneurs "Calamity Jan" and "Scallywag Jake" (below) get into the spirit of the wild Klondike days in their energetic skit for tourists in front of the old North-West Mounted Police barracks, now converted into a gift shop. Carcross, its name derived from "caribou crossing," is located on the north shore of Bennett Lake on the original river route to the Klondike. It is the final resting place of such notable gold rush characters as Dawson Charley, James Mason (Skookum Jim) and, of course, Polly, the Sourdough Parrot (opposite). A celebrity resident of the Caribou Hotel until 1972, Polly outlived many of the stampeders she came over the Chilkoot Pass with in 1898. One of countless remnants of that era, this old prospector's boot (above) lies in a forgotten corner.

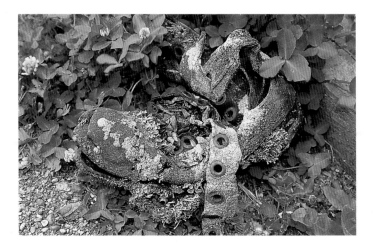

ABOVE: A PROSPECTOR'S BOOT

OPPOSITE: GRAVE OF POLLY, THE SOURDOUGH PARROT

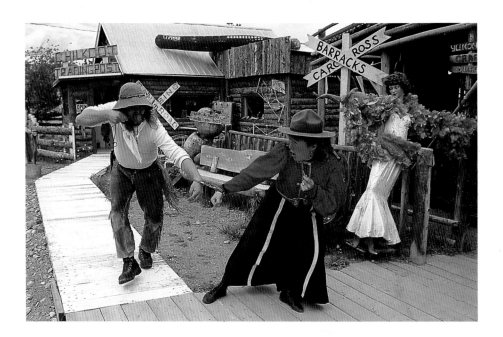

"CALAMITY JAN" AND "SCALLYWAG JAKE" IN CARCROSS, ON THE SOUTH KLONDIKE HIGHWAY

"POLLY" BORN 1850, DIED 1972
UNDER THIS SOD LIES A SOURDOUGH PARROT
ITS HEART WAS GOLD, PURE FOURTEEN CARAT,
POLLY NOW CAN SPREAD HER WINGS
LEAVING BEHIND ALL EARTHLY THINGS,
SHE RANKS IN FAME AS OUR DEAR DEPARTED,
A JUST REWARD FOR BEING GOOD HEARTED.

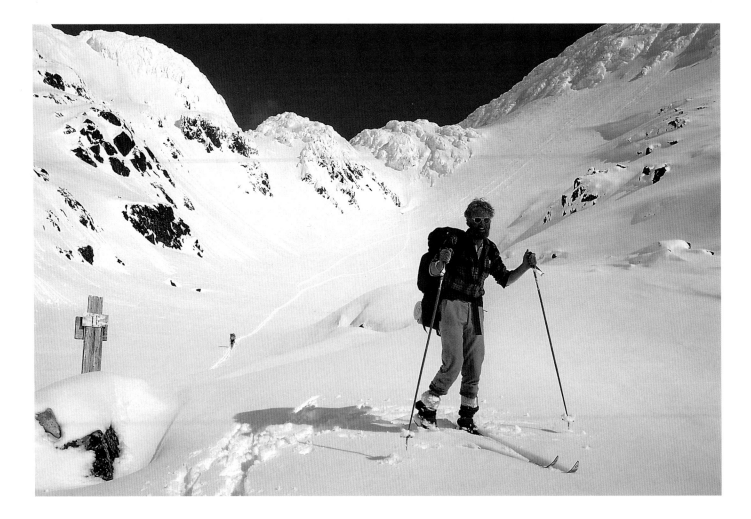

SKIING OVER CHILKOOT PASS

I n the autumn of 1897, the streets of Skagway bustled as prospectors straggled toward Chilkoot Pass (right, bottom) to Bennett Lake and then down the Yukon River to the Klondike gold fields, 600 miles away. Today, hikers and skiers (above) need only three days to retrace the historic route over the pass, and they carry a single backpack instead of the year's worth of supplies once stipulated by Canadian authorities. In the Skagway Museum (right, top), a display of the stampeders' obligatory "ton" of supplies gives the visitor some idea of the challenge they faced.

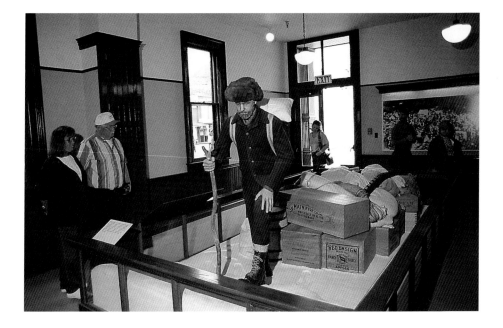

SKAGWAY MUSEUM, SKAGWAY, ALASKA

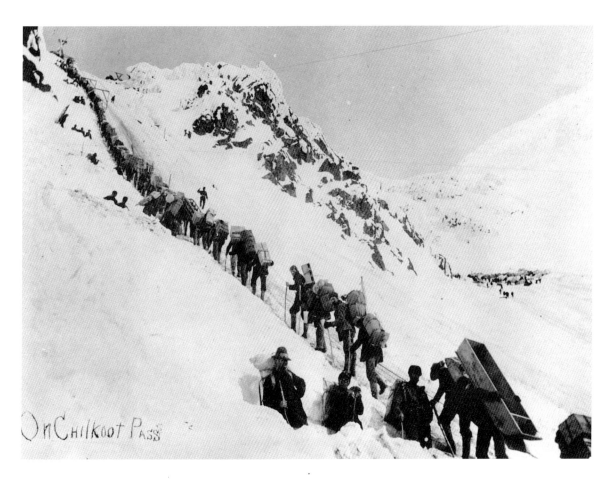

CHILKOOT PASS CIRCA 1897

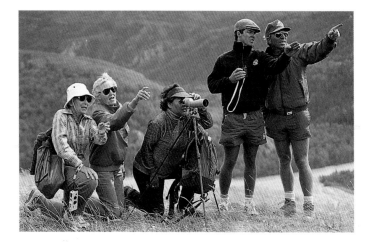

TATSHENSHINI RIVER RAFTERS

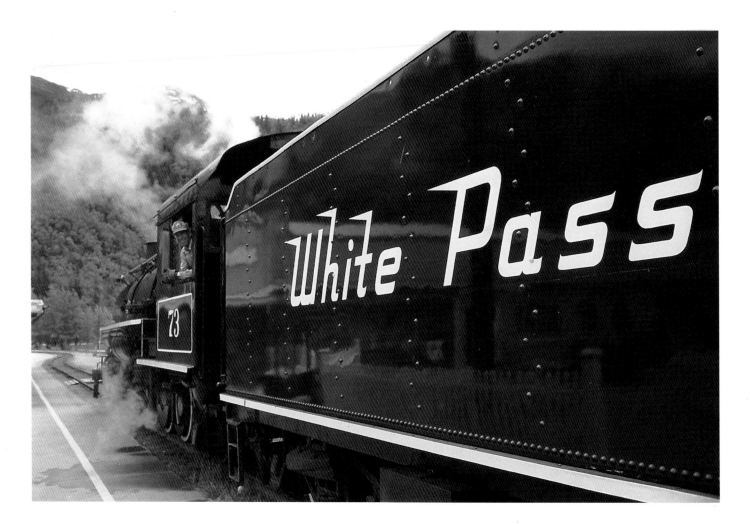

WHITE PASS & YUKON ROUTE RAILWAY,
SKAGWAY, ALASKA

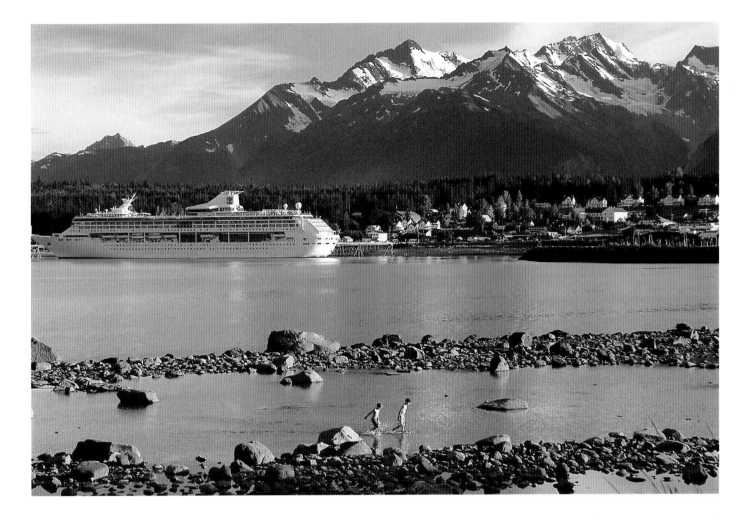

CRUISE SHIP IN HAINES, ALASKA

Although the wild days of the Klondike are but memories, it can be said that a gold rush of another kind is now taking place: industrial tourism. Thousands of eager sightseers come every summer on cruise ships via the Inside Passage along the coast of British Columbia and the Alaska panhandle to Skagway and Haines (above), both in Alaska. The narrow-gauge White Pass & Yukon Route Railway (left, bottom), completed in 1900, no longer offers service all the way to Whitehorse from Skagway, but it still provides tourists with an exciting trip into the Coast Mountains. For the more adventurous, a guided multiday raft trip on the Tatshenshini River is the ultimate northern experience.

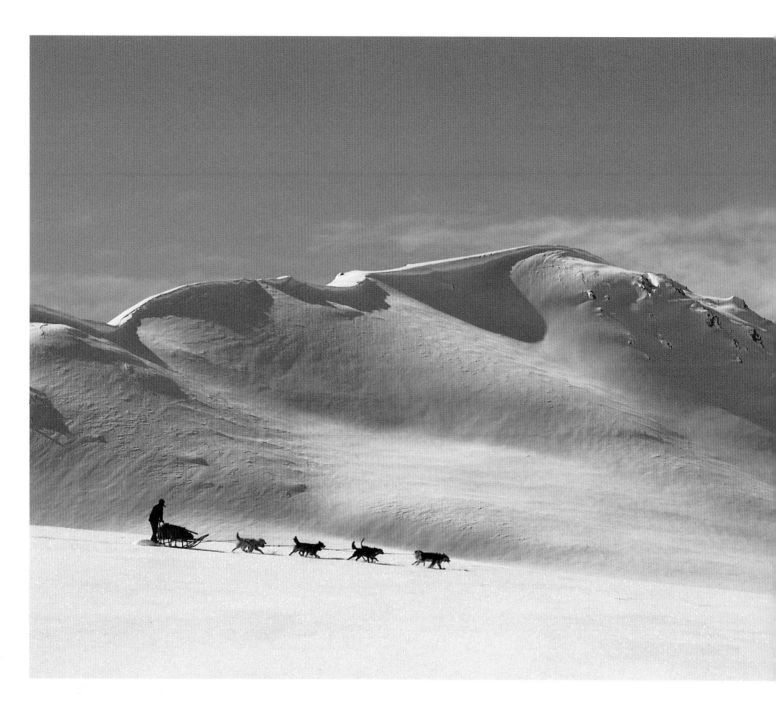

DOGSLEDDING ALONG THE HAINES HIGHWAY

A man who lives close to the land, trapper Jurg Hofer (right, top) spent many years in the front ranges of the St. Elias Mountains along the Haines Highway in northern British Columbia (above), where he ran a trapline nearly the size of his native Switzerland. His log cabin at Squaw Creek (right, bottom) is typical of hundreds all over the Yukon that are still being used by trappers, hunters and full-time backcountry residents.

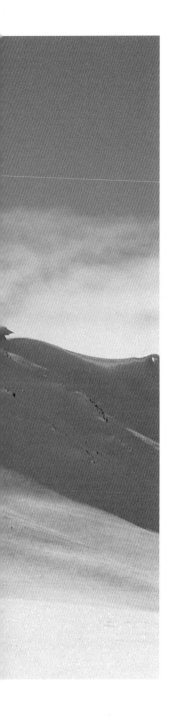

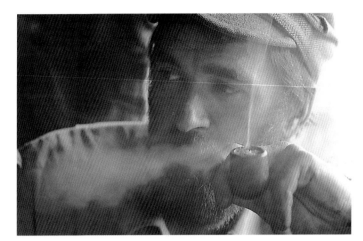

JURG HOFER

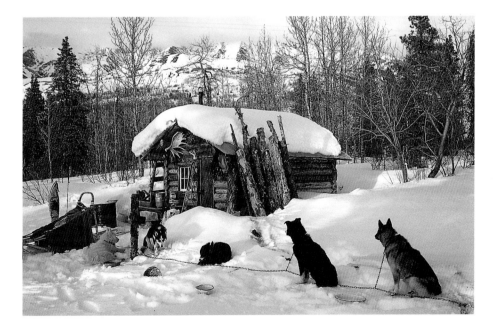

JURG HOFER'S CABIN

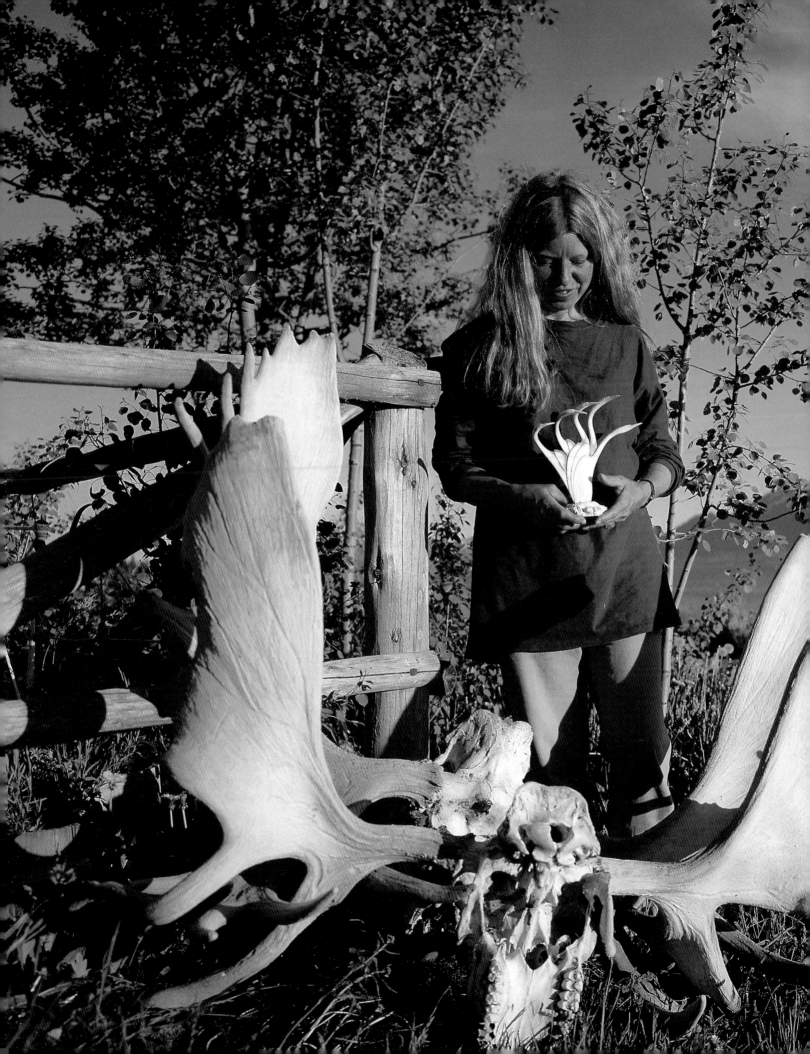

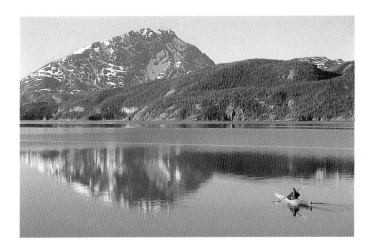

EXPLORING ATLIN LAKE AND THE COAST
MOUNTAINS BY SEA KAYAK

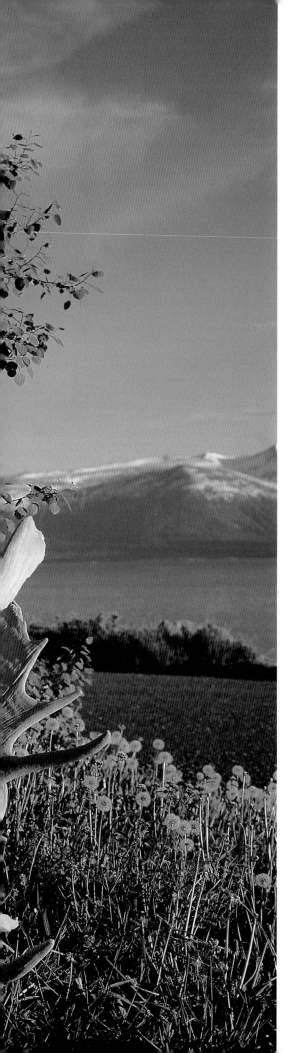

A picturesque town tucked into the Coast Mountains of northwest British Columbia, Atlin has more connections with the Yukon than with its own province, since its only road leads north to Whitehorse. The Atlin area is one of the oldest gold producers in the north and has its share of mining characters. Because of its beauty and remoteness, it has also attracted other types of refugees from the south, including artist Maureen Morris (left), who creates exquisite sculptures from antlers. The interlocked moose antlers by her house are a grim record of a fight between two bulls who finally died of starvation. It's an easy job to launch a sea kayak (above) from the shores of Atlin Lake to explore the surrounding Coast Mountains.

ARTIST MAUREEN MORRIS

BURNED-OUT STERN-WHEELER
S.S. TUTSHI IN CARCROSS

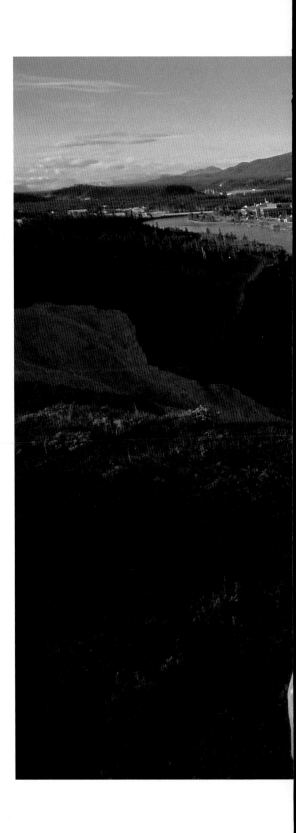

Whitehorse, the capital and supply center of the Yukon Territory, originated as a temporary stopping point for those headed for the Klondike along the Yukon River. The town took its name from the White Horse Rapids, whose foamy white crests reminded early prospectors of horses' manes. In this historical photograph (right) juxtaposed with a contemporary scene, stern-wheelers travel up and down the Yukon River, bringing supplies from the river's mouth, about 1,930 miles downstream at St. Michael, Alaska. In its heyday, more than 200 stern-wheelers plied the river. The charred paddle wheel silhouetted here (above) is all that remains of the *S.S. Tutshi* in Carcross.

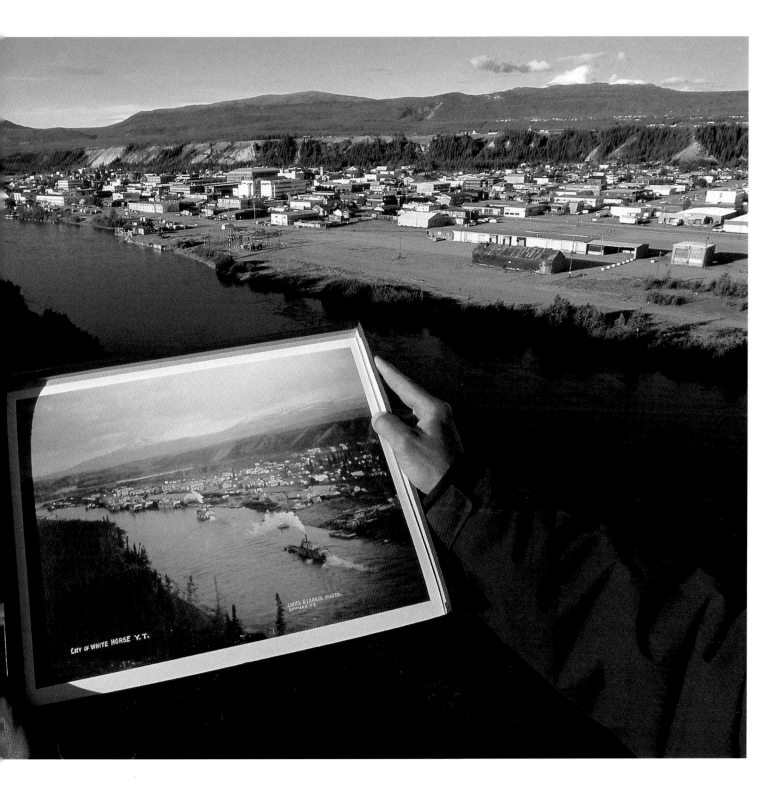

CITY OF WHITE HORSE Y.T.

ADAMS & LARKIN PHOTO.
DAWSON Y.T.

WHITEHORSE, PAST AND PRESENT

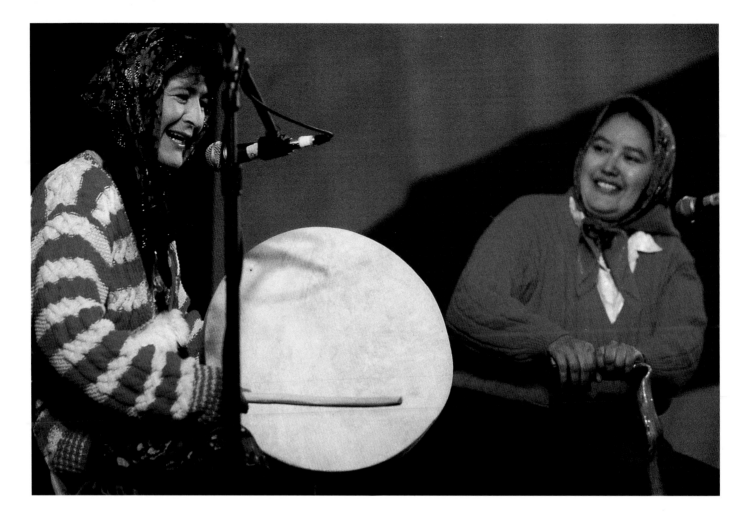

SARAH AND SUSIE AT THE YUKON
INTERNATIONAL STORYTELLING FESTIVAL

Every June, the Yukon International Storytelling Festival in Whitehorse (right) attracts storytellers from all over the territory and beyond. Angela Sydney, one of the last speakers of the Tagish language, was the inspiration for the first festival in 1988. Besides providing entertainment for all ages, the weekend-long event celebrates the strong oral traditions of the Yukon's First Nations peoples. The irreverent comedy duo, Sarah and Susie, played by Jackie Bear and Sharon Shorty (above), parody their elders in skits that renew the laughter and the wisdom of the old ways.

AT THE YUKON INTERNATIONAL
STORYTELLING FESTIVAL

ST. ELIAS MOUNTAINS/ KLUANE NATIONAL PARK

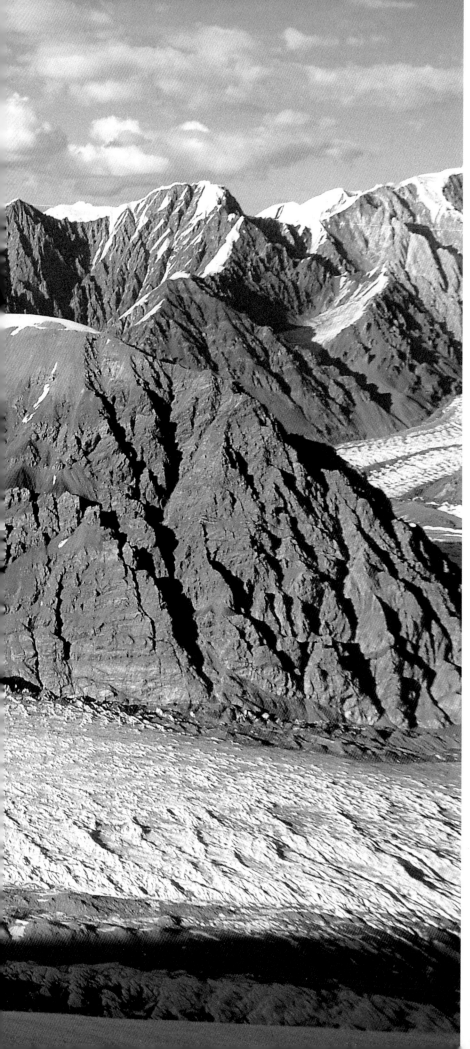

The St. Elias Mountains, Canada's highest range, inspire superlatives vaunting their physical, esthetic and mystical qualities. Their countless peaks of pristine rock and snow stand like frozen sentinels above the world's largest nonpolar ice fields. In recognition of these stunning natural properties, Kluane National Park, which encompasses the St. Elias Mountains on the Yukon side, and Wrangell-St. Elias National Park and Preserve, in Alaska, were jointly declared a United Nations World Heritage Site in 1979. Together with the newly created Tatshenshini-Alsek Wilderness Provincial Park in British Columbia and Glacier Bay National Park and Preserve in Alaska, they make up the largest protected area in the world, approximately 21 million acres. Taken in 1995 from the east ridge of Mount Steele, Canada's sixth-highest peak, this photograph profiles one of the members of an expedition commemorating 100 years of North-West Mounted Police (NWMP) presence in the Yukon. The peak was named for Sam Steele, the officer who commanded the NWMP posts at White and Chilkoot passes and brought law and order to Dawson at the height of the gold rush. Below are the remnants of the Steele Glacier, a "galloping" expanse of ice that attracted the attention of scientists when it surged up to 82 feet a day in the 1960s.

CLIMBER ON MOUNT STEELE
IN THE ST. ELIAS MOUNTAINS

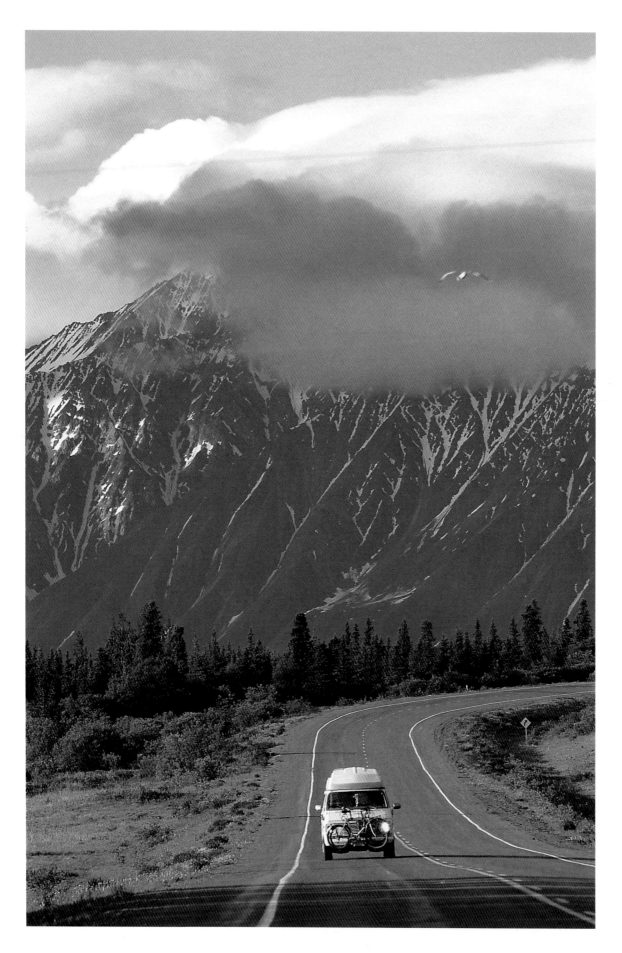

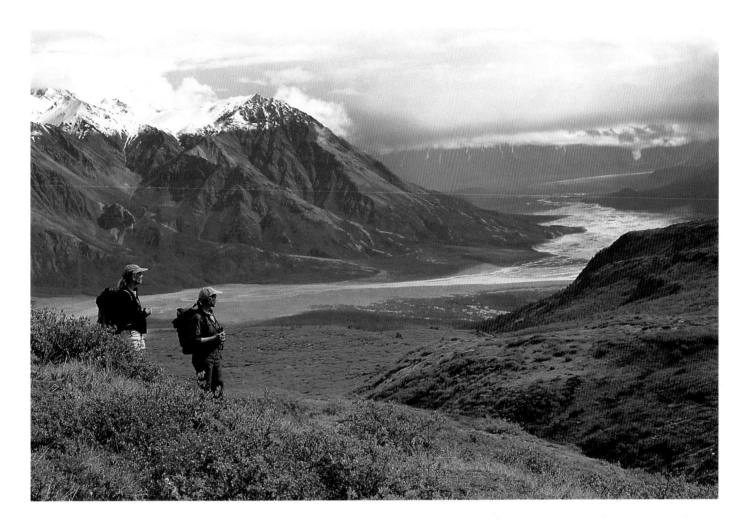

ABOVE: HIKING UP THE SLIMS RIVER VALLEY
ONTO THE SHEEP-BULLION PLATEAU

LEFT: DRIVING THE ALASKA HIGHWAY, NORTH OF
HAINES JUNCTION, ALONG THE FRONT RANGES
OF THE ST. ELIAS MOUNTAINS

A two-hour drive west of Whitehorse, Kluane National Park is one of the richest areas for wildlife and native plants in northern Canada. More than 170 bird species inhabit the park, as do many varieties of flowers. Because of the large population of grizzly bears, hikers on the Sheep-Bullion Plateau overlooking the Slims River Valley (above) are always wary of chance encounters.

One of the common denizens of the north, this red fox (right, top) sets out on its daily rounds in search of field mice. Kathleen Lake (below) offers abundant opportunities for good fishing, boating and hiking. Roadside attractions like this wild vetch (right, bottom) are plentiful, but those who make the extra effort to explore the backcountry in Kluane will find even richer rewards.

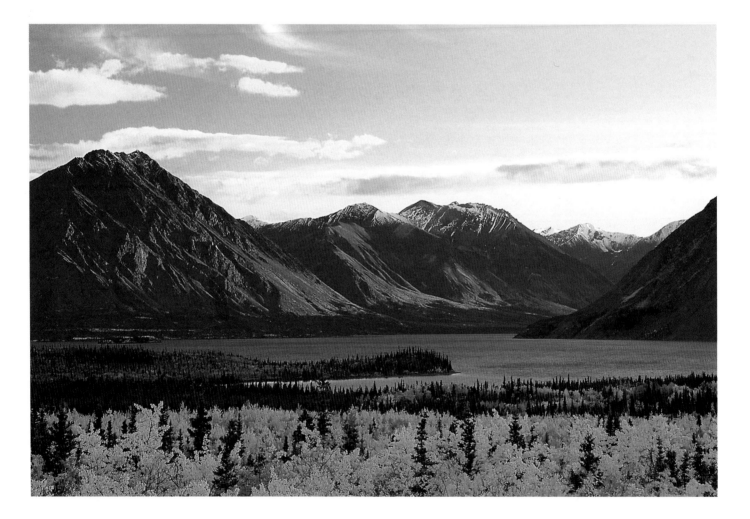

KATHLEEN LAKE, FROM THE HAINES HIGHWAY

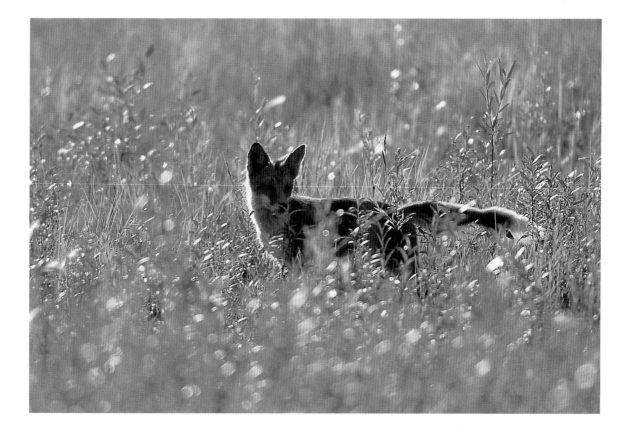

A RED FOX SEARCHES FOR MICE IN THE HIGH GRASS

WILD VETCH BRIGHTENS THE SHOULDER OF THE ALASKA HIGHWAY

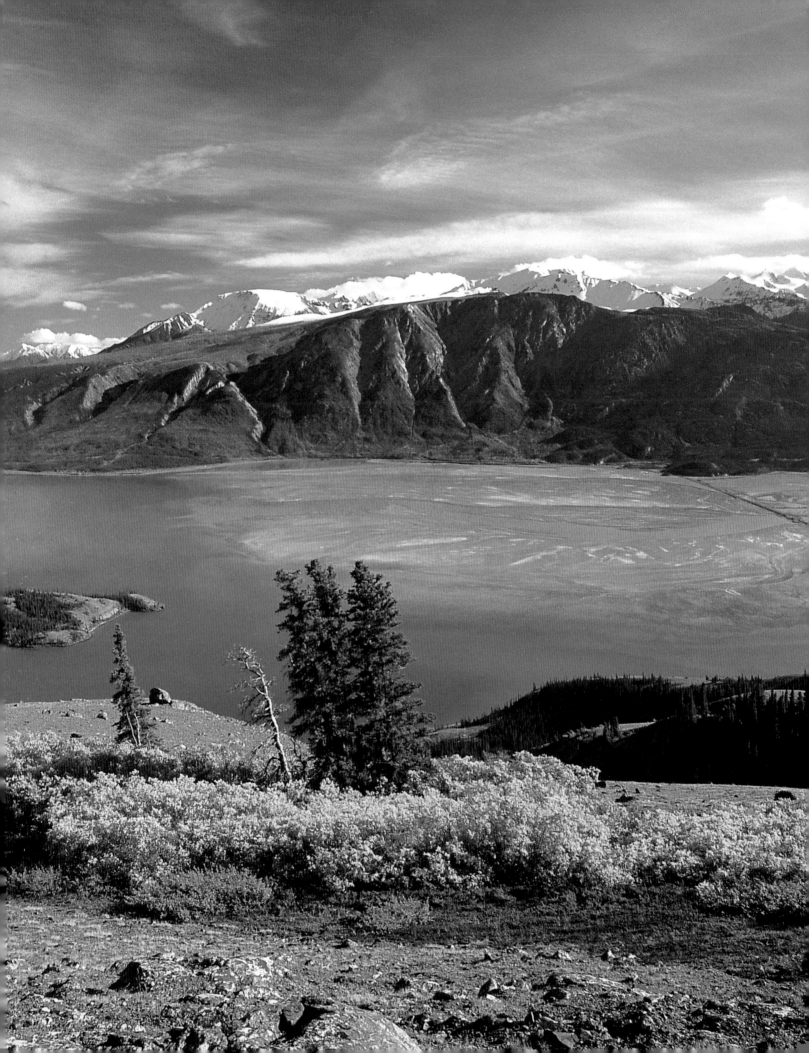

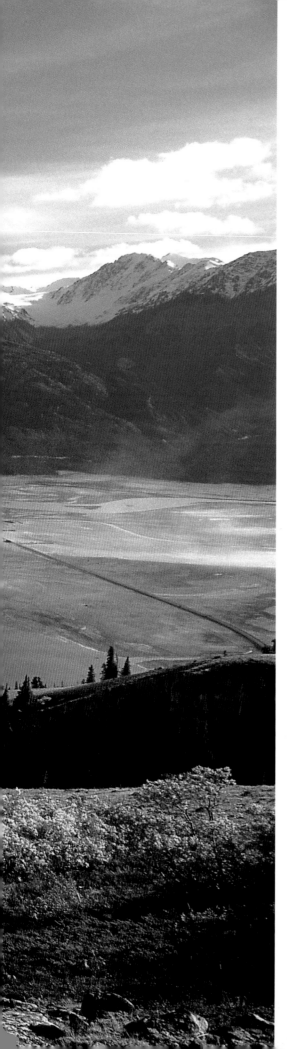

One of the Yukon's largest bodies of water, Kluane Lake (left) derives its name from a Southern Tutchone word meaning "place of many fish." Ron Chambers (below) worked for many years as a warden in Kluane National Park and now operates his own interpretive guiding company. Deputy chief of the Champagne-Aishihik Band, Chambers is a descendant of a Tlingit grandmother and a North-West Mounted Police constable who worked under Sam Steele. The couple met during the gold rush.

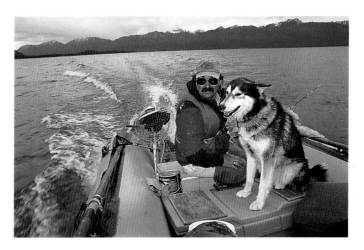

RON CHAMBERS AND HIS DOG KLEE
ON KLUANE LAKE

THE ALASKA HIGHWAY AND THE SOUTHERN END
OF KLUANE LAKE FROM SHEEP MOUNTAIN

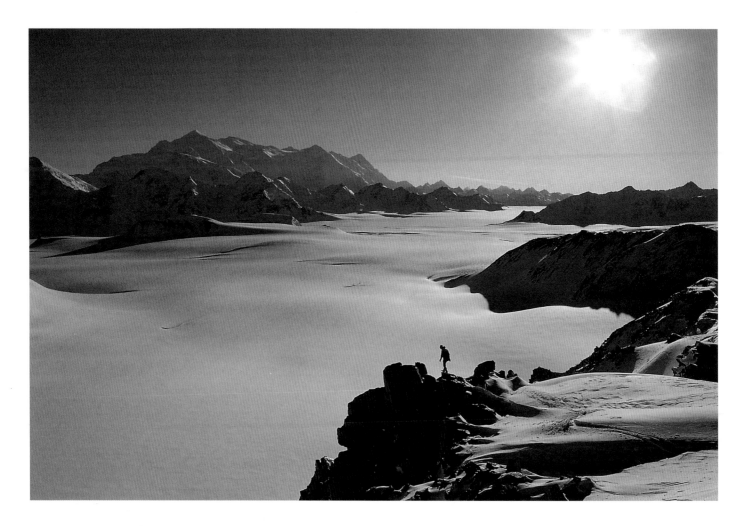

MOUNT LOGAN, CANADA'S
HIGHEST PEAK

Mount Logan (above), at 19,850 feet (6,050 m), reigns in the vast icy wilderness as Canada's highest peak. Named after Sir William Logan, founder and for many years a director of the Geological Survey of Canada, it is, if measured by its base circumference, the most massive mountain in the world. In 1992, a Royal Canadian Geographical Society expedition set out to remeasure its height with the help of satellite surveying techniques. After nearly a month of battling severe cold and wind, team members wrapped themselves in the nation's flag to celebrate their summit success (right).

A CANADIAN TEAM CELEBRATES ITS
ASCENT OF MOUNT LOGAN

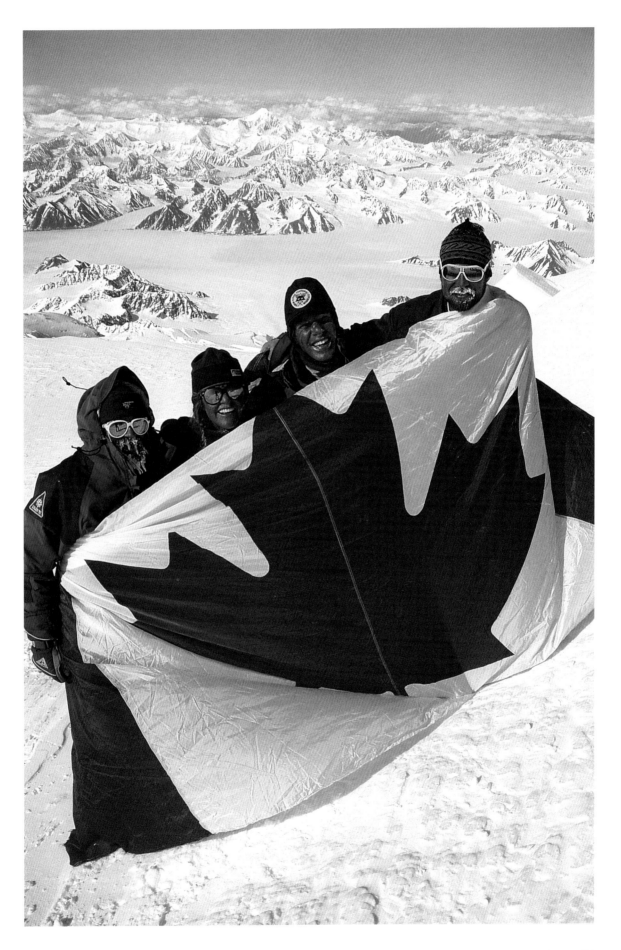

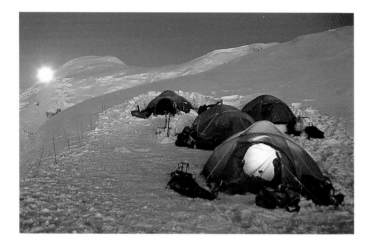

At 18,008 feet (5,489 m), Canada's second-highest and North America's fourth-highest peak, Mount St. Elias (right) was first climbed at the time of the Klondike Gold Rush by an Italian team. Since then, it has seen few ascents on account of its difficulty and the typically bad weather generated by its near neighbor, the Gulf of Alaska. Many lesser peaks, such as Mount Steele (above), at 16,644 feet (5,073 m), offer similar challenges to the mountaineer. Camps must be well secured, because snowstorms can move in within hours, plunging temperatures to minus 40 degrees F, even in late spring, the season most favored by mountaineers.

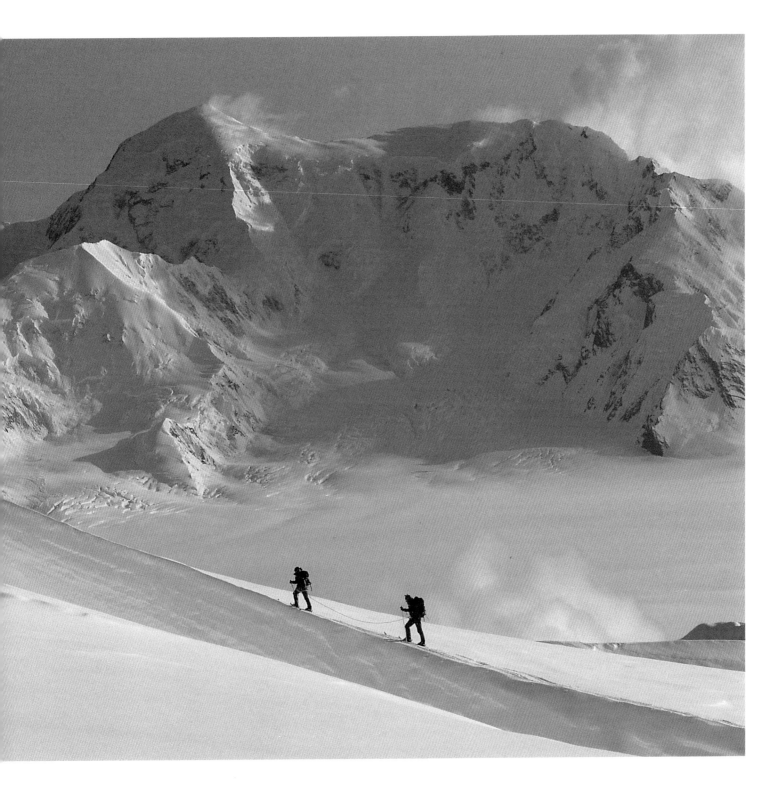

CLIMBERS ON MOUNT LOGAN VIEW
MOUNT ST. ELIAS IN THE DISTANCE

A raft journey along the Alsek—the largest river to carve its way through the formidable St. Elias Mountains—offers untold scenic gems. A vantage point on Goatherd Mountain (opposite) gives a unique glimpse of an environment that harks back to the last ice age. The Lowell Glacier, winding down the valley from mounts Kennedy, Hubbard and Alverstone, comes to an abrupt end in Lowell Lake (below), where 30-yard-high chunks of ice calve into the lake with thunderous splashes. In the mid-1800s, a huge glacial dam was formed when the Lowell Glacier surged across the Alsek River, forcing it against the base of Goatherd Mountain. The lake that was created backed up all the way to the site of present-day Haines Junction. Farther down the river, rafters glide alongside a berg on Alsek Lake (above).

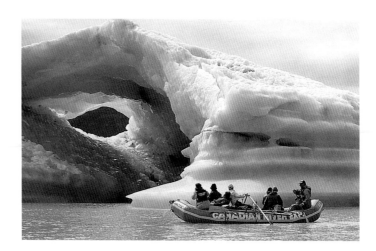

ABOVE: ICEBERG ON ALSEK LAKE, NEAR THE PACIFIC OCEAN

OPPOSITE: HIKERS ON GOATHERD MOUNTAIN ABOVE THE LOWELL GLACIER

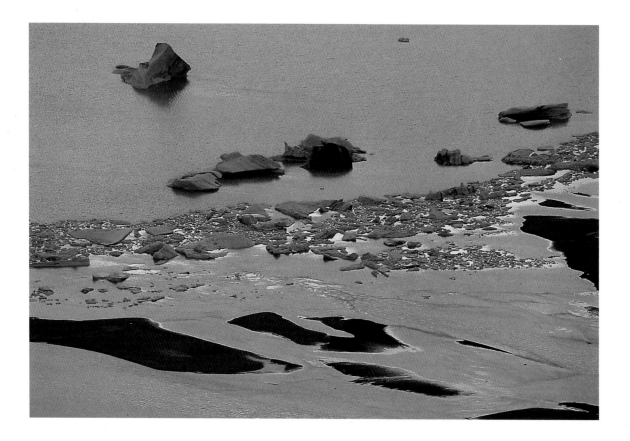

ICEBERGS ON LOWELL LAKE

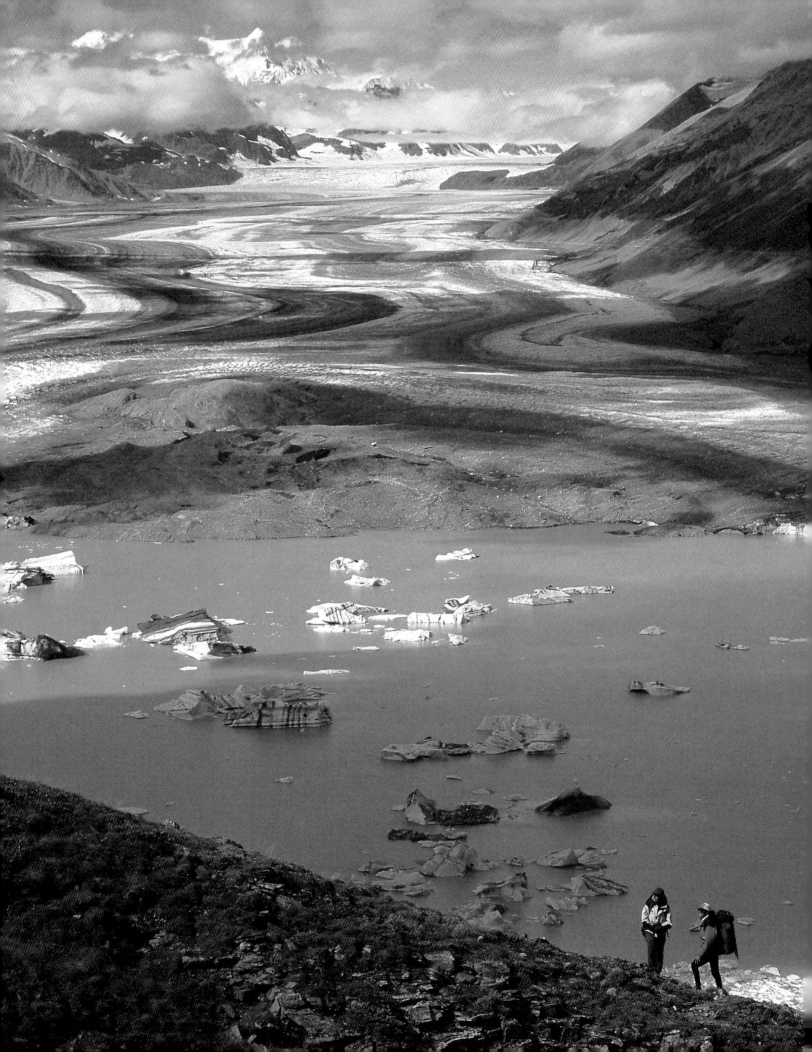

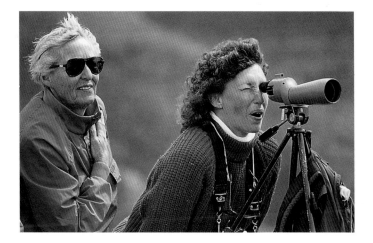

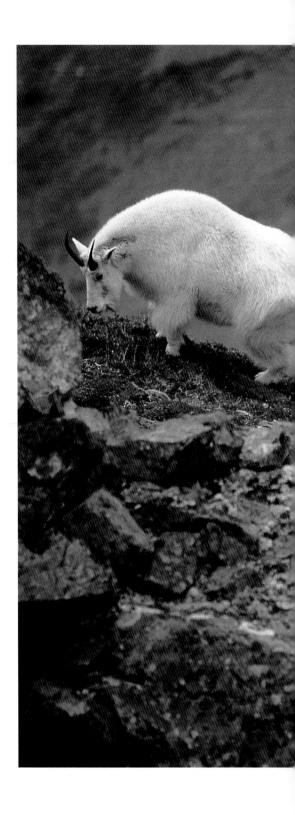

While the core of Kluane National Park is frozen in ice and snow, its outer fringes are more hospitable to people and wildlife alike (above). In its alpine meadows, tundra and forested valleys resides a diverse range of species representative of Canada's West Coast, the Arctic, the western mountains, the northern prairies and the Asian steppes. Goatherd Mountain, above the Alsek River, represents the northernmost range of mountain goats in the Yukon (right).

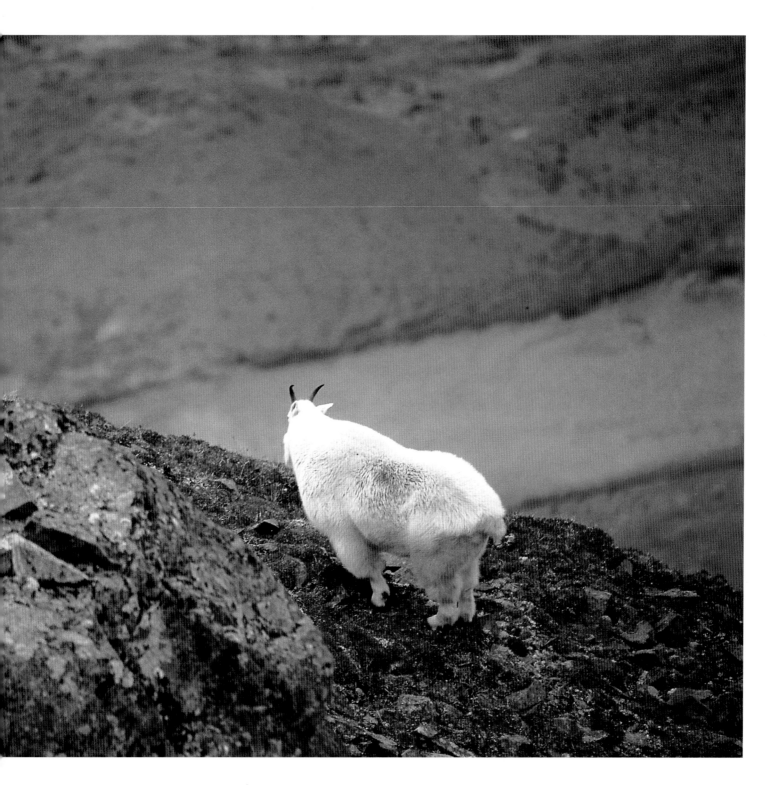

MOUNTAIN GOATS ON GOATHERD MOUNTAIN

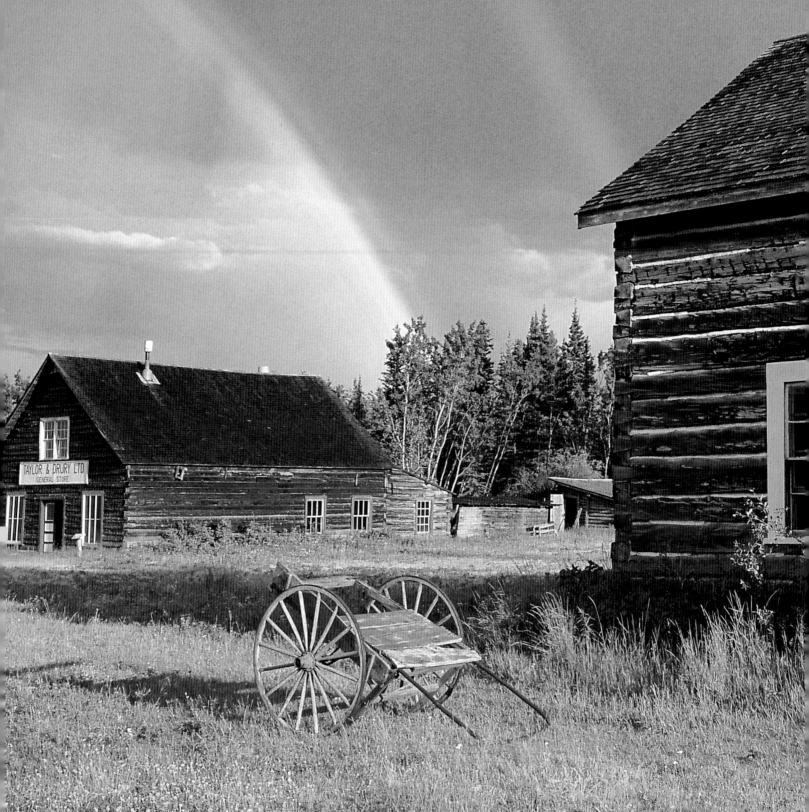

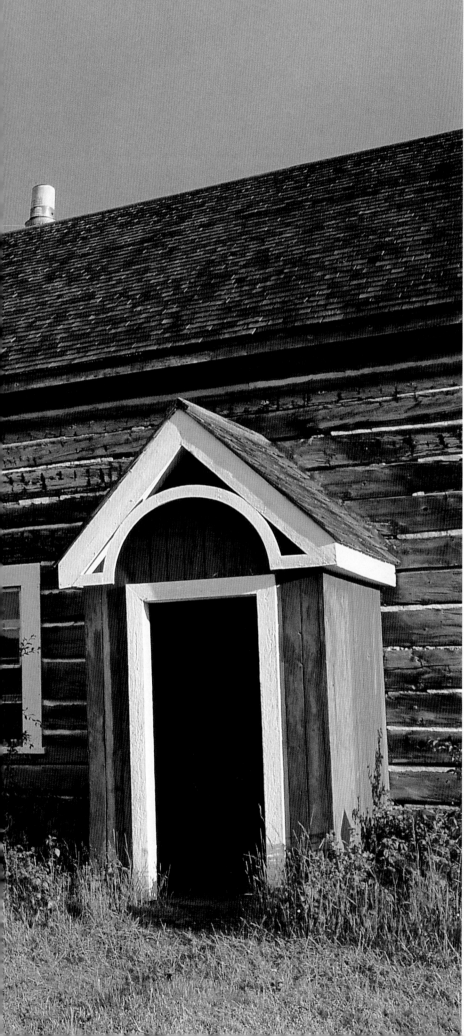

Rolling hills covered with black spruce and aspen and several major river systems that drain into the Tintina Trench characterize the central Yukon plateau. Human history and the natural setting have evolved a fascinating, if sometimes conflicting, marriage. The search for fur and later for mineral wealth has been a dominant force in the region's economy. Neatly arranged along an airy bench beside the Yukon River, Fort Selkirk (left), built in 1848, is one of the few communities to pre-date the gold rush. Prior to the establishment of this Hudson's Bay Company trading post at the confluence of the Pelly and Yukon rivers, the area was a traditional meeting place for First Nations peoples. The Northern Tutchones (the Selkirk Indian Band) met in this area at the end of every summer to trade with the Chilkat, a Tlingit tribe from the coast. Today, Fort Selkirk is a living cultural and historic site with carefully restored buildings such as the Anglican church. Fort Selkirk can be reached by boat from Minto or by float-plane from Pelly Crossing. Canoeists on the Yukon River call in for at least a day to wander around the fascinating site.

HISTORIC FORT SELKIRK
ON THE YUKON RIVER

OLD MINING SHACK ON KENO HILL

While the Klondike region is famous for its gold-mining history, the Keno City area, at the end of Silver Trail Highway #11, became known for a rich deposit of silver ore discovered in 1919. Today, the surrounding hills can be explored along the old mining trails (left), which include a drivable road to a great viewpoint at 6,000 feet near the top of Keno Hill (below).

CAIRN AND SIGNPOST
ON KENO HILL

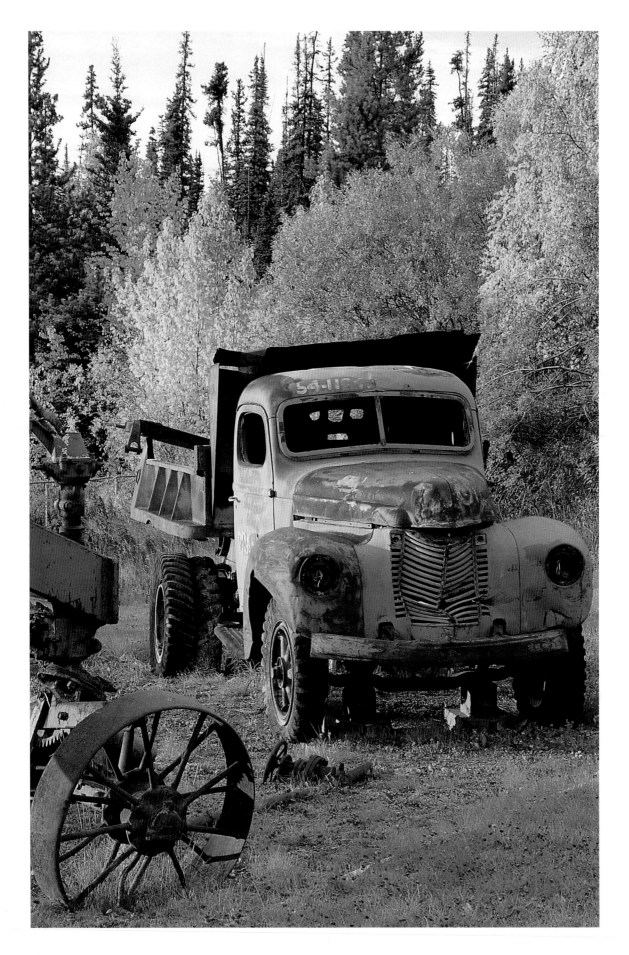

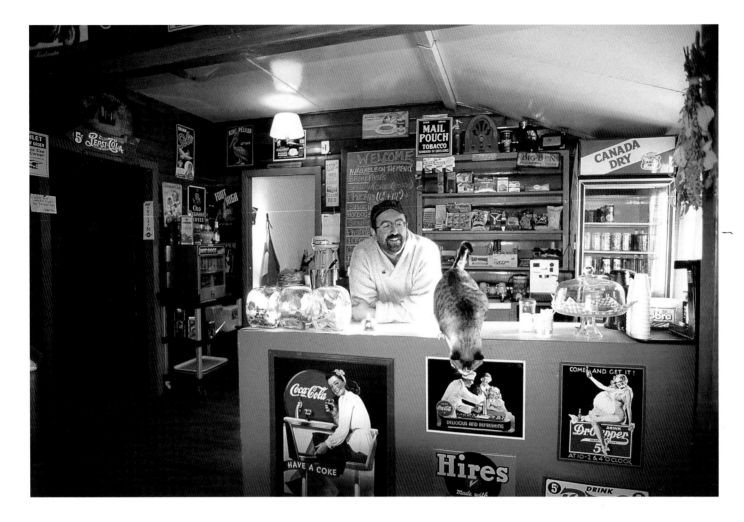

ABOVE: MIKE MANCINI, KENO MAYOR AND OWNER
OF KENO SNACK BAR

LEFT: ABANDONED TRUCK ON THE CANOL ROAD

Some 20 people continue to call the "ghost" hamlet of
Keno home, including mayor Mike Mancini, seen above
in his café. In addition to his civic duties, Mike also manages
the small but vital Keno City Mining Museum. Other relics of
a bygone era include road-building machinery (left), a reminder
of the war effort in the north during World War II. The Canol
Road, short for "Canadian oil," was constructed by the Ameri-
can armed forces in the 1940s to facilitate the laying of an oil
pipeline from Norman Wells, Northwest Territories, to White-
horse. The South Canol Road is still intact today, but the
North Canol is maintained only as far as Macmillan Pass
on the border.

STORM OVER LITTLE SALMON LAKE

Lying in the rain shadow of the Coast and St. Elias
mountains, central Yukon receives relatively little rain,
and what does fall often comes in the form of sun showers like
this summer storm over Little Salmon Lake (above). Farther
south, near Sheldon Lake along the North Canol Road, this
abandoned cabin (right) makes a fine lunch spot for an angler.

OLD CABIN ON THE CANOL ROAD

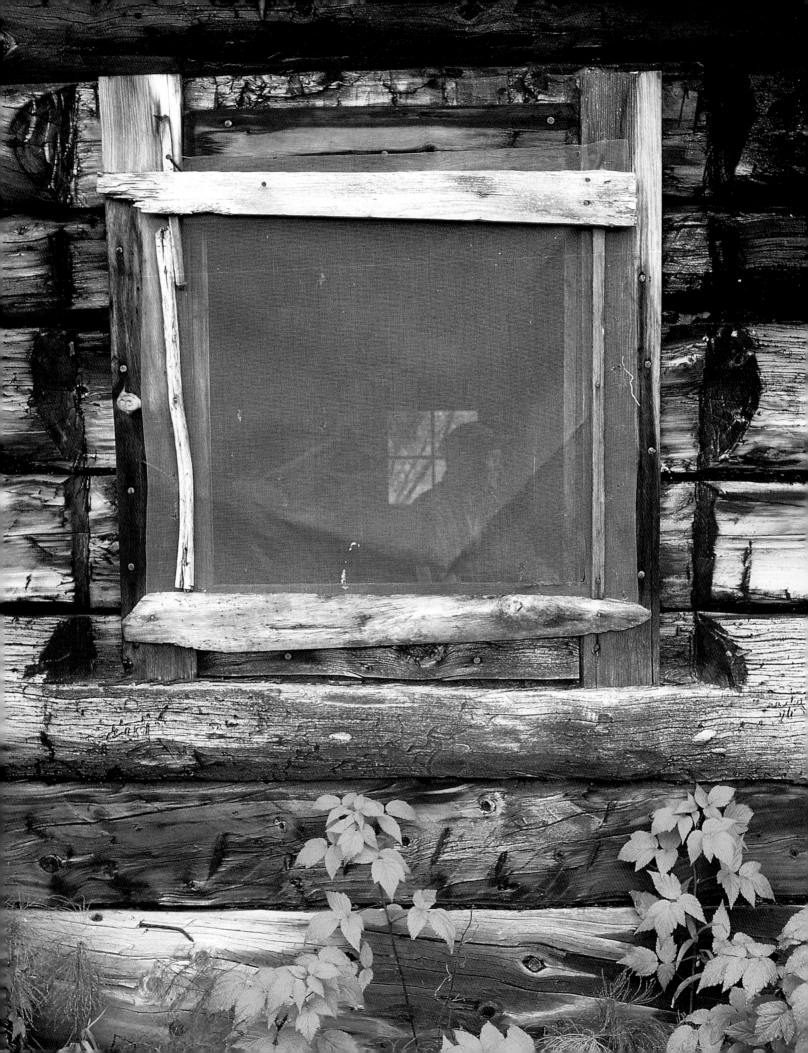

LUCY SANDERSON PAINTING A MURAL
IN PELLY CROSSING

A rtist Lucy Sanderson (left), a daughter of the pioneer Van Bibber family, paints a mural in her family home honoring the Pelly River Indian Band. In 1898, Ira Van Bibber came to the Klondike from West Virginia with his two brothers and fell in love with the country. He married a native woman named Eliza, settled in the Pelly Crossing area and became one of the best big-game guides in the Yukon. His family, which included 14 children, lived off the land, fishing and trapping in the wildlife-rich mountain range nearby, now the McArthur Wildlife Sanctuary. The rain nurtures roadside grasses, and they in turn provide a nutrient-rich salad for this black bear (below).

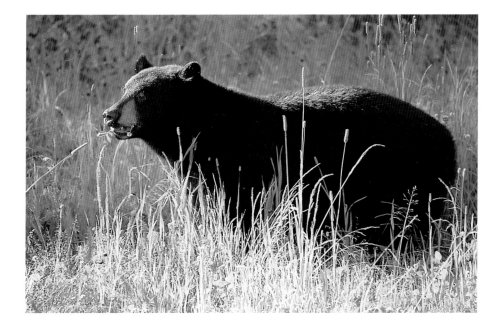

A BLACK BEAR FEEDING ON GRASS
ALONG THE ROADSIDE

THE KLONDIKE

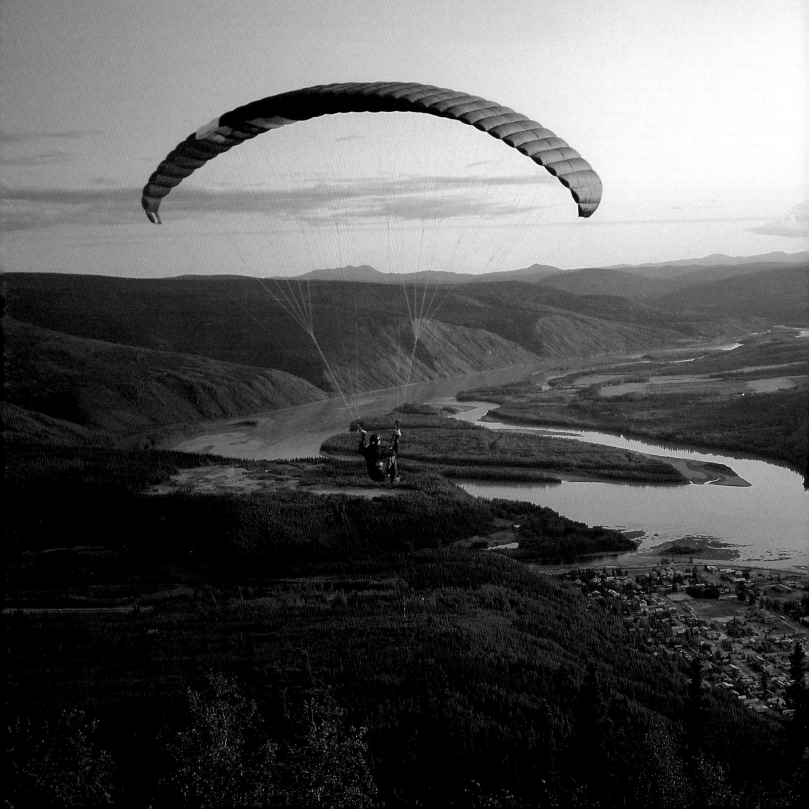

Larry Vezina has an unconventional view of his town as he soars from the Midnight Dome, 1,800 feet (550 m) above Dawson City. At the upper edge of town, the confluence of the Klondike and Yukon rivers is visible. Bonanza Creek, where it all began on August 17, 1896, when George Carmack, Dawson Charley and Skookum Jim made their find, is just out of sight in the wooded hills to the left. At the height of the gold rush, Dawson was bursting with a population of 30,000. Today, it is still a vibrant place in the summer, but the number of permanent residents has dropped to a more manageable 2,000. Those in the service industry play host to upward of 60,000 visitors a summer. Located at the intersection of three main roads— the Top of the World, Dempster and Klondike highways—Dawson is well situated for vacationers who want a taste of unique history and wilderness.

PARAGLIDER LARRY VEZINA SOARS
OVER DAWSON CITY

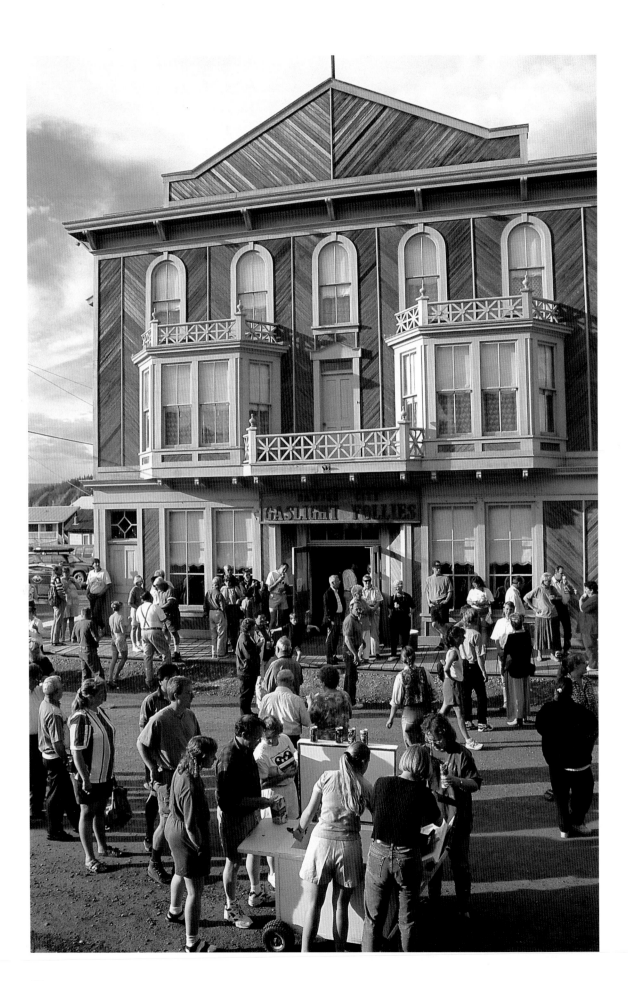

illed as the biggest and best
theater north of San Francisco
and west of Winnipeg, the Palace Grand
Theatre opened in 1899. The building
was restored in 1962, and today, a vaude-
ville-style musical revue known as *The
Gaslight Follies* continues to entertain
the crowds. Members of the audience
are often roped into lively and humorous
plays (right) that revive the Yukon's color-
ful past. During intermission, theater-
goers step outside for a breath of air and
an ice-cream cone (left).

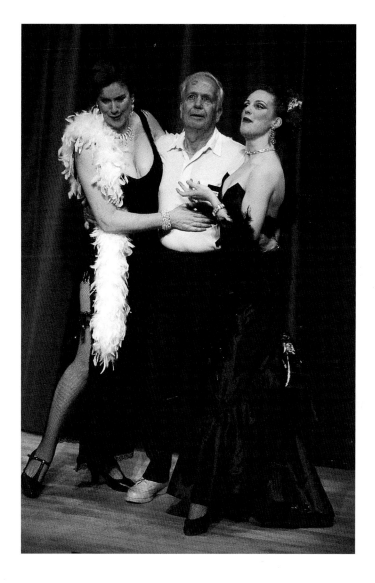

A MEMBER OF *THE GASLIGHT FOLLIES'*
AUDIENCE JOINS IN THE FUN

DAWSON'S PALACE GRAND THEATRE,
BUILT IN 1899

PARKS CANADA TOUR IN DAWSON CITY

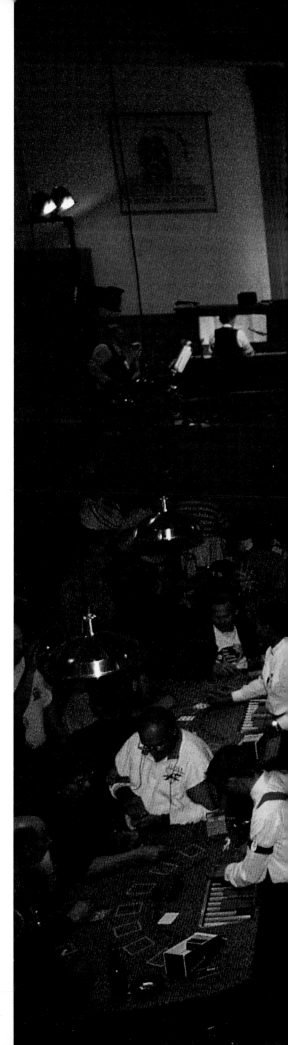

Once threatened by Dawson's shifting permafrost, many classic Victorian buildings have been restored by Parks Canada and are now maintained as national historic sites. A Parks Canada tour guide (above) brings to life tales from the past. Nearby, in Diamond Tooth Gertie's (right), tourists rub shoulders with locals at the gambling tables while taking in a nightly song-and-dance stage show. The ever popular hangout is named after Gertie Lovejoy, a bona fide Yukon dance-hall queen who made a fortune unloading gold nuggets from miners Her nickname was inspired by the sparkling diamond wedged between her two front teeth.

DIAMOND TOOTH GERTIE'S

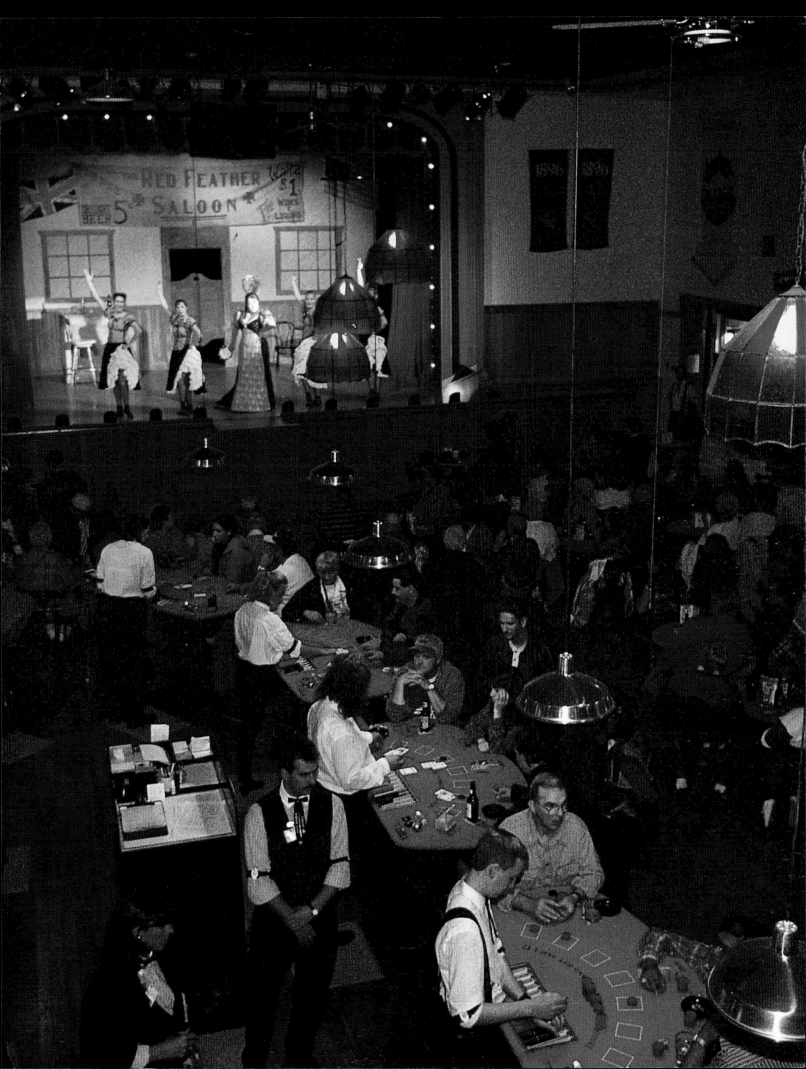

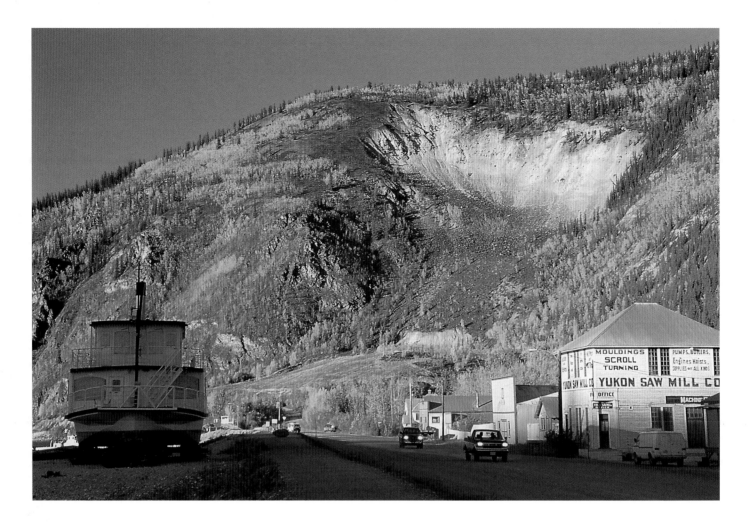

VIEW DOWN DAWSON'S FRONT STREET

In a short but daylight-filled growing season, farmer Grant Dowdell and his family have carved out an agricultural niche for themselves on an island 7½ miles upstream from Dawson on the Yukon River (right, bottom). Their market garden, the most northwestern in Canada, supplies Dawson with fresh vegetables throughout the summer. With its small-town atmosphere and beautiful surroundings, Dawson is a favorite summer haunt for tourists and locals alike (right, top). Vehicles enter town from the scenic Top of the World Highway, which connects Dawson to Eagle, Alaska. Another road leads several miles to the viewpoint on top of the Midnight Dome, above the rock slide in the photograph above.

A SUMMER SCENE IN
DAWSON CITY

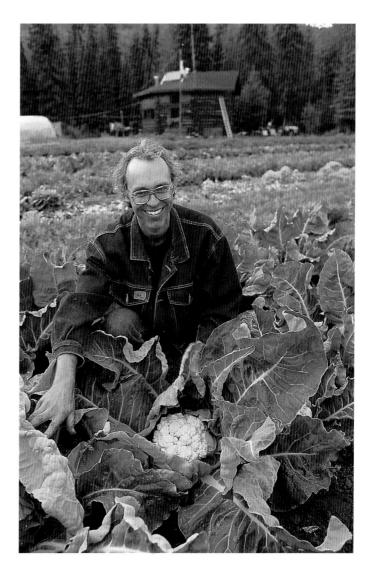

GRANT DOWDELL ON THE FAMILY FARM ON AN
ISLAND IN THE YUKON RIVER

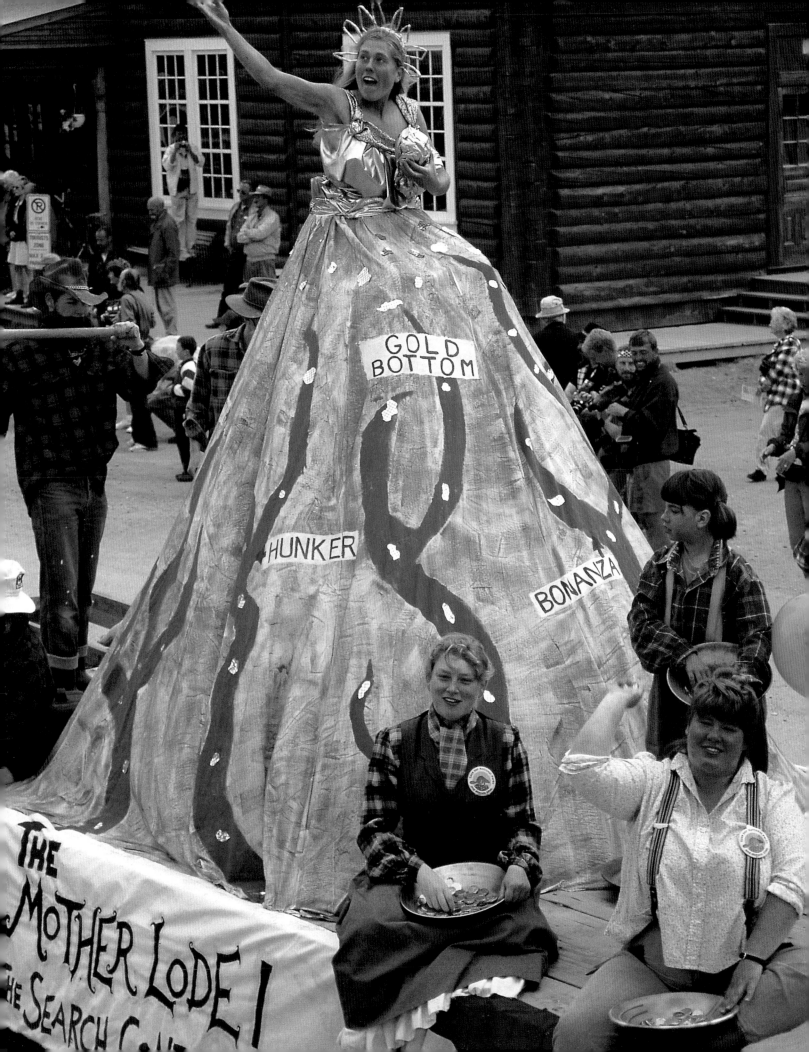

GOLD BOTTOM

HUNKER

BONANZA

THE MOTHER LODE
THE SEARCH C...

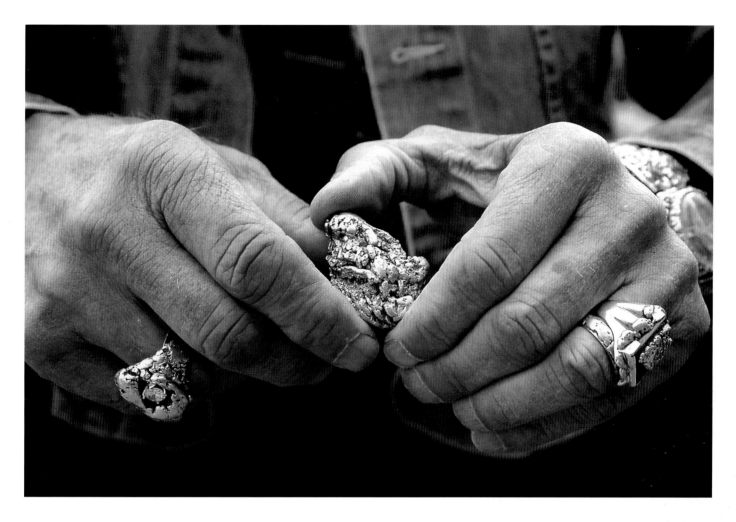

ABOVE: A GOLD NUGGET

LEFT: THE DISCOVERY DAY PARADE CELEBRATES
THE ORIGINAL BONANZA CREEK CLAIM

The dazzling 4-ounce nugget (above) held by miner and writer Jimmy Simpson is a sample of what drew gold seekers to this area in the first place. Followed by silver and lead, gold still accounts for the largest mineral income in the territory. In 1995, $159 million in revenue was generated by gold miners. The sign on this float in the Discovery Day parade (left) confirms that the search continues. Discovery Claim on Bonanza Creek, now a Parks Canada Historic Site, was the start of it all in 1896. Hundreds of tourists like this man from Arkansas (right) try their luck panning for gold for free here every summer.

A TOURIST PANNING FOR GOLD

PHOTOGRAPH (LEFT) BY DAVID TRATTLES

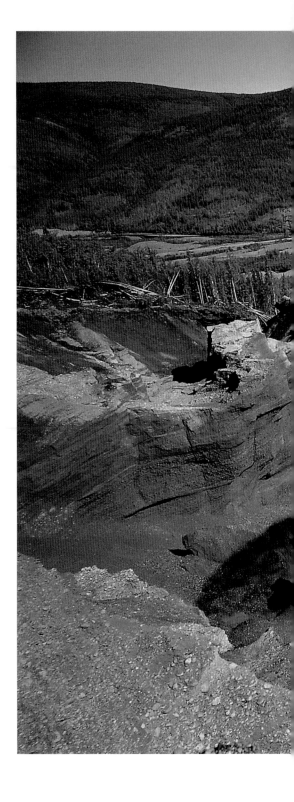

After hand-mining became less profitable, miners built huge shiplike dredges that continued to operate until the early 1960s. The restored dredge number 4 on Bonanza Creek (below) is the largest wooden-hull dredge in the world. It dug a channel and pulled itself along, processing 600 tons of gravel per hour, and almost 50 pounds of gold was cleaned out of the sluices every three to four days. Resembling castings left by giant earthworms, the tailings from this and other dredges fill the lower Klondike Valley. At the height of the "neo" gold rush in 1980, when gold prices were at an all-time high of $800 an ounce, this hydraulic monitor (right) washed the gravel of Jackson Hill into a sluice box above the Klondike River.

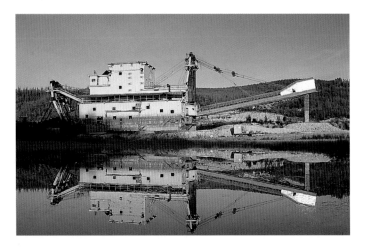

THE WORLD'S LARGEST WOODEN-HULL DREDGE

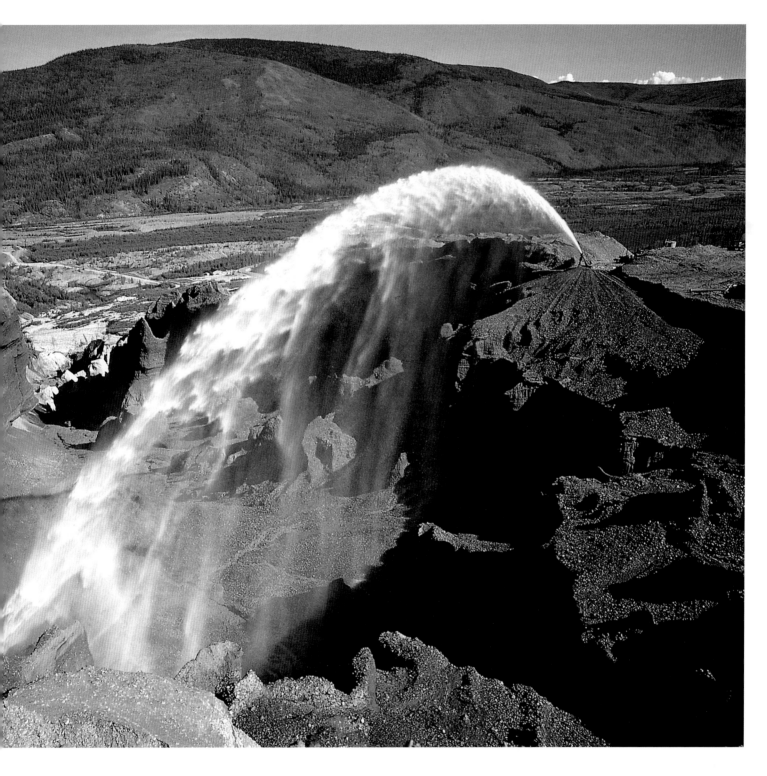

HYDRAULIC MINING ABOVE THE KLONDIKE RIVER

Bill Claxton and Leslie Chapman (below) have created their own miniature dredge (right), similar in principle to the giant ones near Dawson, to mine the placer gravel of Fortymile River. When the creeks freeze up in autumn, most gold miners move back to town or head south. But this couple, along with their now teenaged children, have thrived in isolation for the past 20 years, growing their own vegetables in summer and traveling to town for supplies.

ABOVE: ASPEN TURNING GOLDEN
NEAR DAWSON CITY

OPPOSITE: MINIATURE DREDGE ON
FORTYMILE RIVER

MINERS BILL CLAXTON AND
LESLIE CHAPMAN

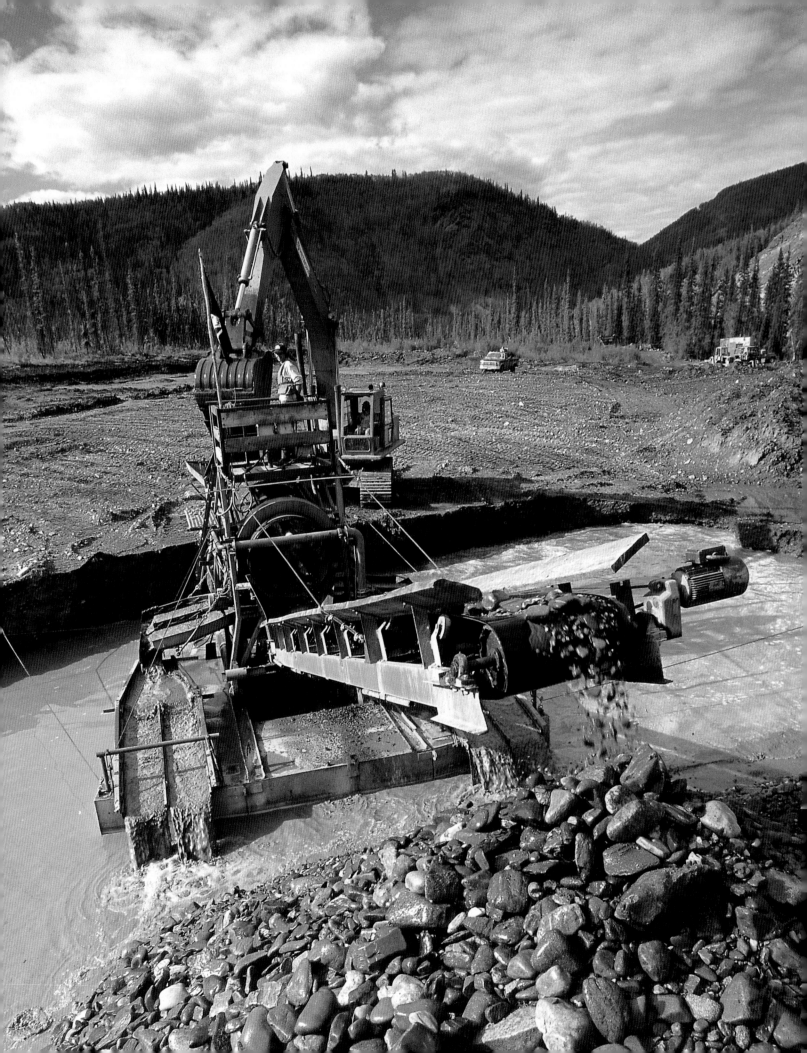

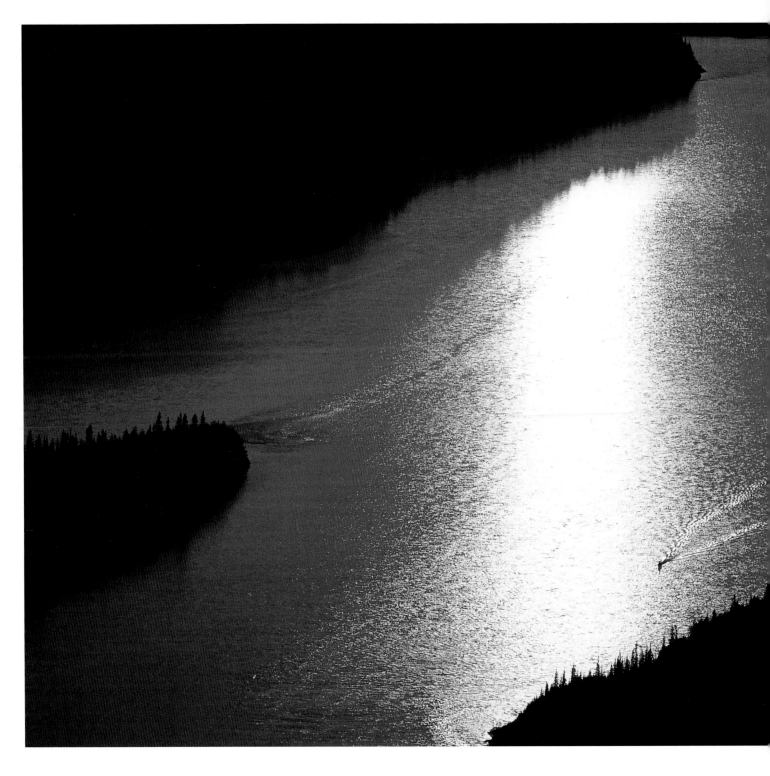

THE YUKON RIVER AT MIDNIGHT FROM
THE MIDNIGHT DOME

The wake of a riverboat creases the golden waters of the mighty Yukon River as it pushes upstream between Moosehide and Dawson (left). Despite an extensive network of roads, riverboats still ply the major river systems of the Yukon on short-haul voyages to permanent and summer encampments. A young German couple, among the legion of foreign tourists lured to the territory's unspoiled and historic riches every year, take a break from their canoe trip down the Yukon River at this cabin near the mouth of Fortymile River (below). The discovery of gold here in 1886 led to the Klondike strike 10 years later.

CANOEISTS AT A CABIN ON THE
HISTORIC FORTYMILE RIVER

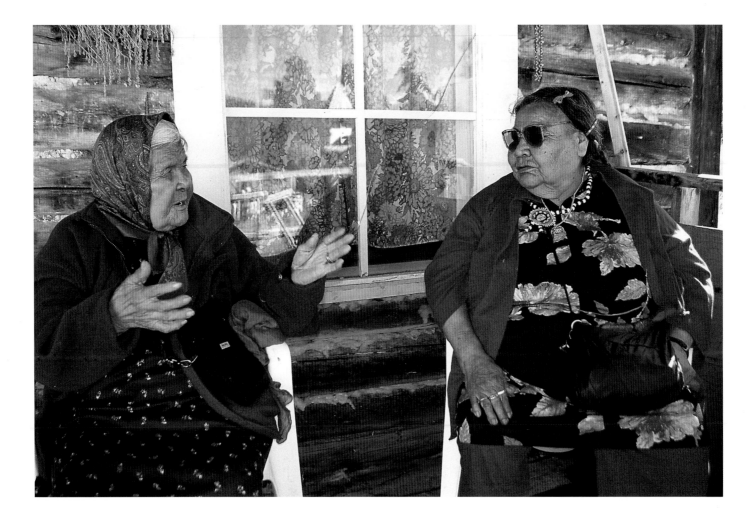

ELDER ANNIE HENRY WITH LENA CHRISTIANSEN

Taking steps to revive traditional culture, the Tr'ondek Hwech'in (Han) Indian Band hosts a festive annual gathering of native and non-native participants at Moosehide, a few miles downstream from Dawson. Wearing ancestral dress handmade of buckskin, volunteers Lisa Anderson and Madeleine "Mado" DeRepentigny (right) help make this annual event a success. Annie Henry (above), seen here with Lena Christiansen, was born near the turn of the century. Annie and her husband Joe, who celebrated their 75th wedding anniversary in 1996, have figured prominently in the history of the region. Joe is credited with scouting the roadway for the surveyors of the Dempster Highway.

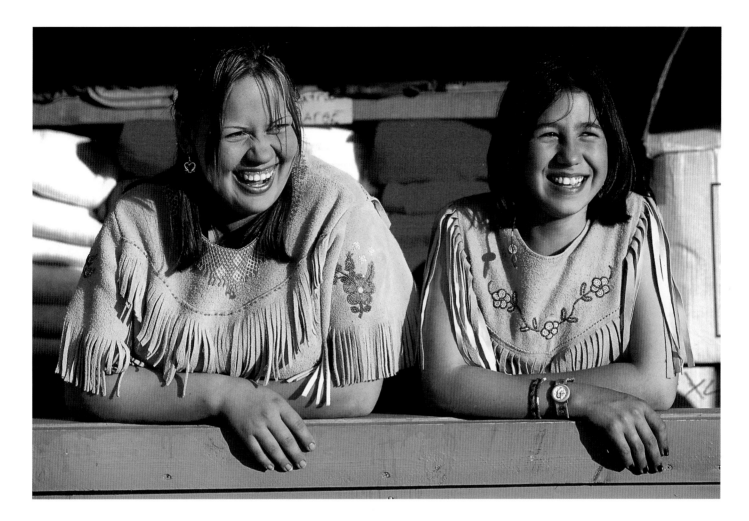

LISA ANDERSON AND "MADO" DEREPENTIGNY
IN ANCESTRAL DRESS

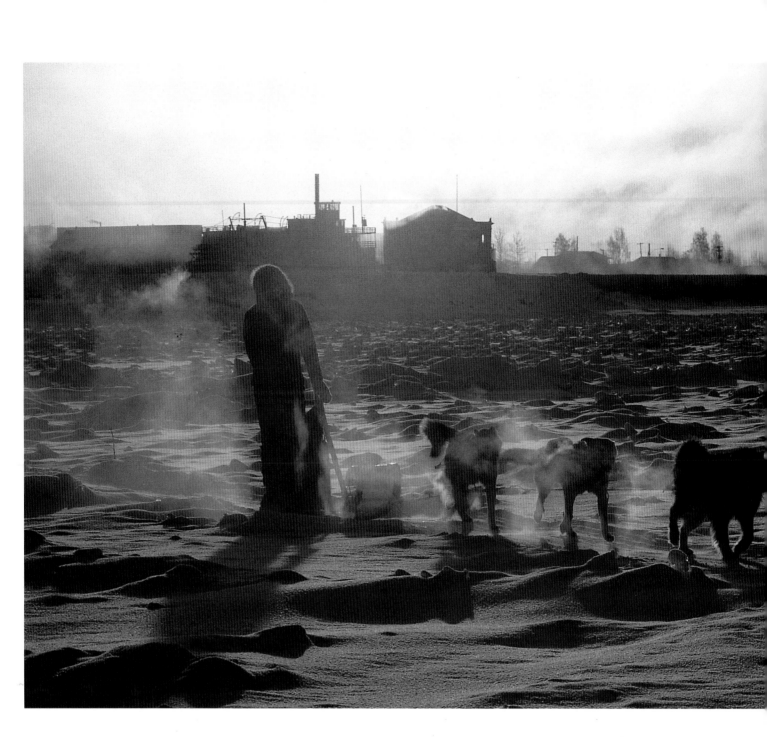

DAWSON RESIDENT JOHN LODDER AND HIS DOGS

In the dead of winter, when the sun brightens the sky above Dawson City for a mere five hours a day, residents become more selective about outdoor activities. In the early 1980s, Dawson resident John Lodder (below) made his living trapping. When he was in town, he exercised his dogs along the frozen Yukon River even on days when the temperature dropped to minus 40 degrees F. While some northern trappers still use working dogs, dog racing as a recreational sport has become increasingly popular in recent years. In mid-February, mushers in the annual Yukon Quest International Sled Dog Race stream through Dawson on their journey between Whitehorse and Fairbanks, Alaska. The 1,000-mile race, whose starting point alternates between the two cities from year to year, lasts up to 14 days.

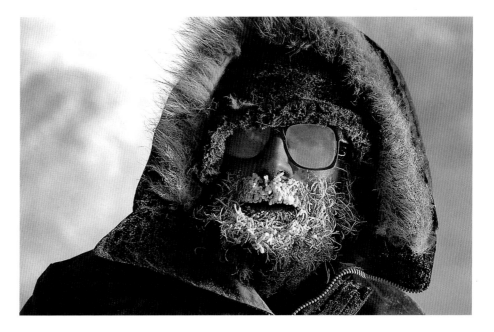

JOHN LODDER

THE NORTH

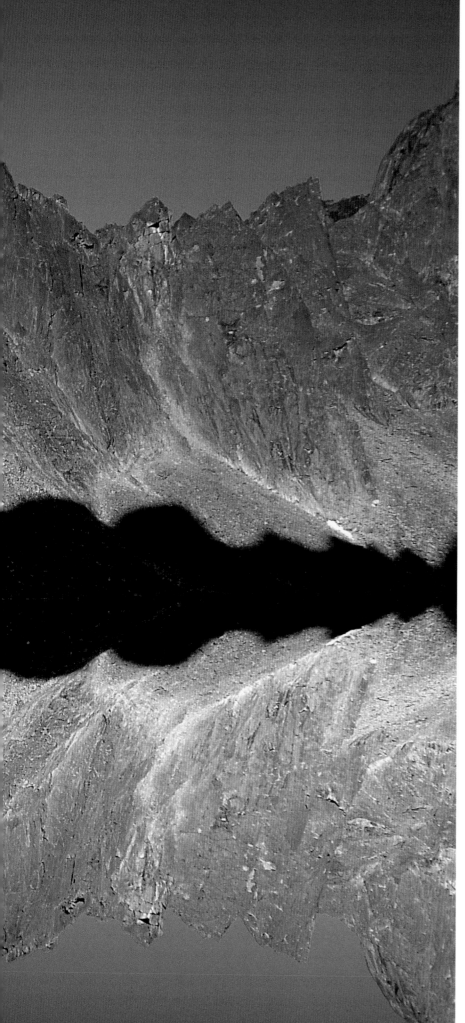

The Yukon's north is a vast and largely uninhabited land of daunting beauty. This is where silence and wilderness still reign with more power and gall than any southern politician could ever muster. In the midst of that expanse, a 100-foot-wide ribbon of gravel lies atop the permafrost, stretching 460 miles northeast from the Klondike gold fields to the Mackenzie Delta in the Northwest Territories. This is the Dempster Highway, Canada's northernmost highway and one of only two roads in North America to cross the Arctic Circle. It offers a unique opportunity to travel through rocky mountain ranges and open tundra without seeing much evidence of human presence. Equally exciting for the adventurous are the off-highway possibilities for hiking, canoeing and horse-packing. The Tombstone Range, in the southern Ogilvie Mountains (left) is one such place.

THE TOMBSTONE RANGE
REFLECTED IN TWIN LAKES

FRESH GRAYLING

A dventure tourism, the Yukon's emerging central industry,
relies completely on the preservation of the territory's
most precious resource: wilderness. Outfitting companies
and individual travelers are drawn to the remote Wernecke
Mountains, north and east of Mayo, for superb canoeing,
hiking, fishing (above) and wildlife-viewing opportunities. A
floatplane delivers whitewater canoeists to Duo Lakes (right),
the starting point of a two-week trip on the Snake River. After
a portage to the shallow river, the loaded canoes must be
dragged and pushed for the first couple of hours until deeper
water is reached.

CANOEISTS ARRIVE BY PLANE AT DUO LAKES
FOR THE START OF A SNAKE RIVER CANOE TRIP

96

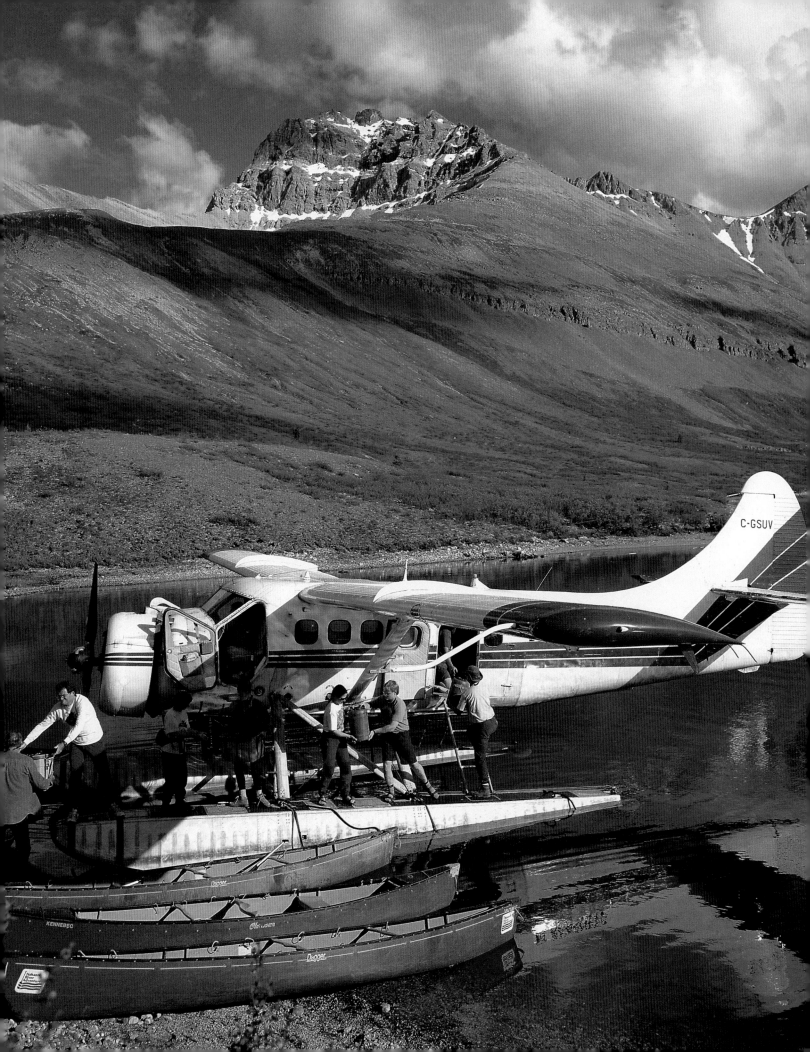

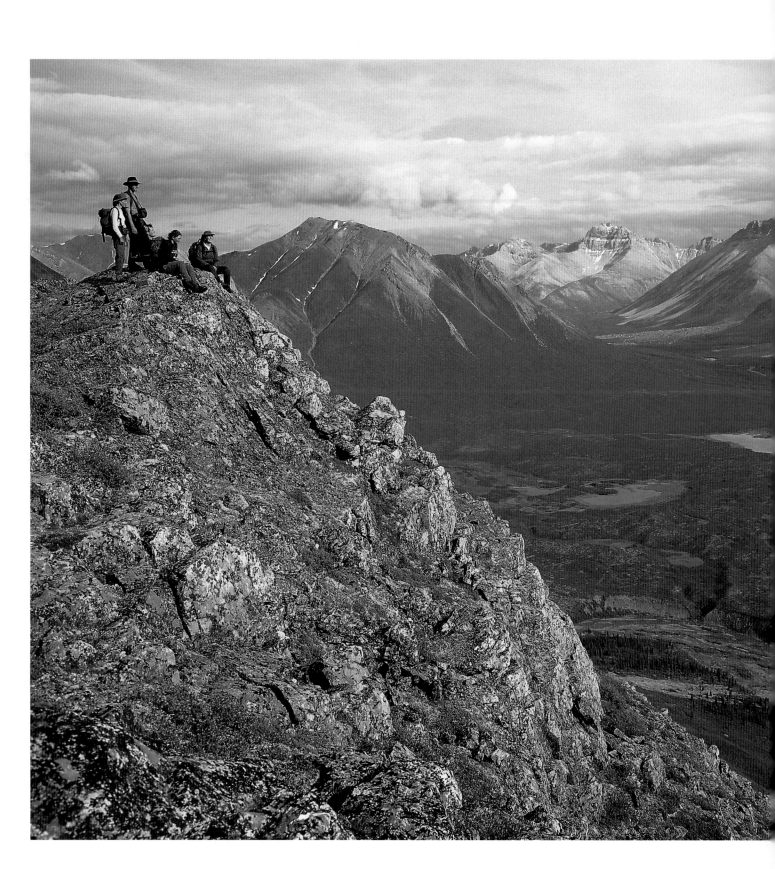

HIKING ABOVE THE SNAKE RIVER, WERNECKE MOUNTAINS

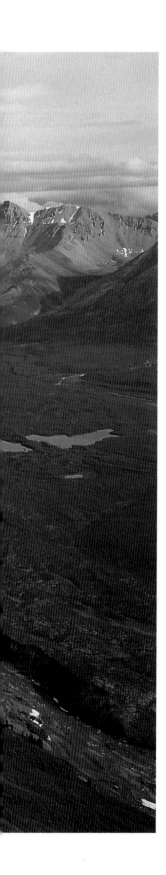

The Snake River watershed, which empties into the Peel River and eventually the mighty Mackenzie, includes some of the most magnificent wild mountainscapes and ecologically rich lowlands on the continent (left). Along with the Bonnet Plume and the Wind, the other principal rivers in the Peel drainage, the Snake watershed not only supports northern peoples' way of life but also has an inherent, far-reaching value as unspoiled, intact land. As the Snake flows north, other rivers, such as the glacier-fed Milky, flow into it (below). By the time it hits the Peel, its water is no longer clear but thick and brown.

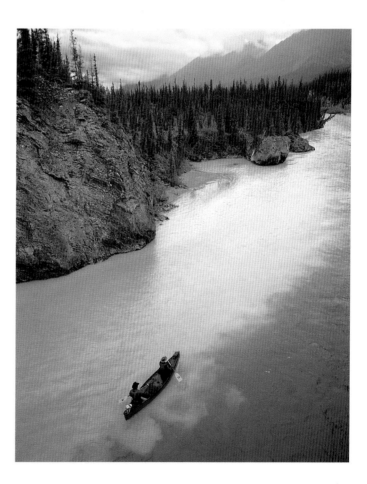

THE GLACIAL WATERS OF THE MILKY RIVER
FEED INTO THE SNAKE RIVER

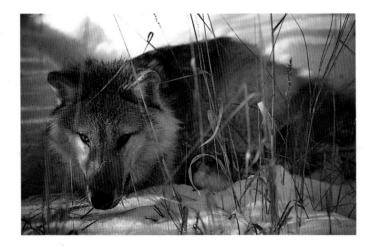

A WOLF IN IVVAVIK NATIONAL PARK

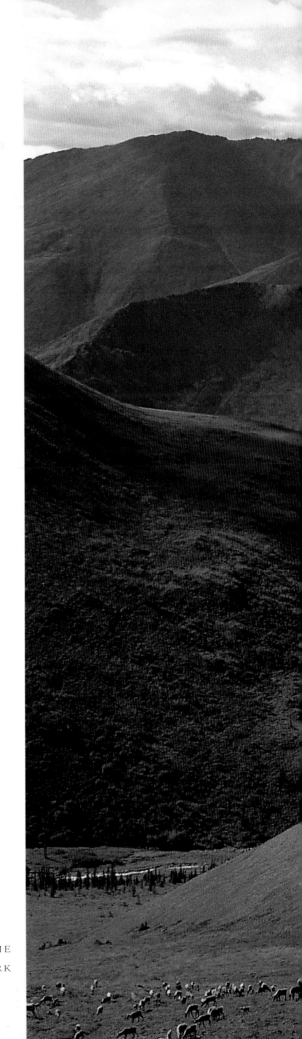

With 150,000 animals that range over a vast expanse of 96,500 square miles, the Porcupine caribou herd is one of the largest in North America. Its calving grounds, known to the Gwich'in as "the sacred place where life begins," are on the coastal plains of Alaska's North Slope and are crucial to the survival of the herd. Ivvavik National Park (right), which encompasses the Firth River and the British Mountains near the Beaufort Sea, and the adjoining Arctic National Wildlife Refuge, in Alaska, help protect a critical part of the herd's range. One of the caribou's predators is the wolf (above), which also preys on moose and Dall's sheep.

THE PORCUPINE CARIBOU HERD IN THE
FIRTH RIVER VALLEY, IVVAVIK NATIONAL PARK

PHOTOGRAPH (TOP) BY NORMAN BARICHELLO

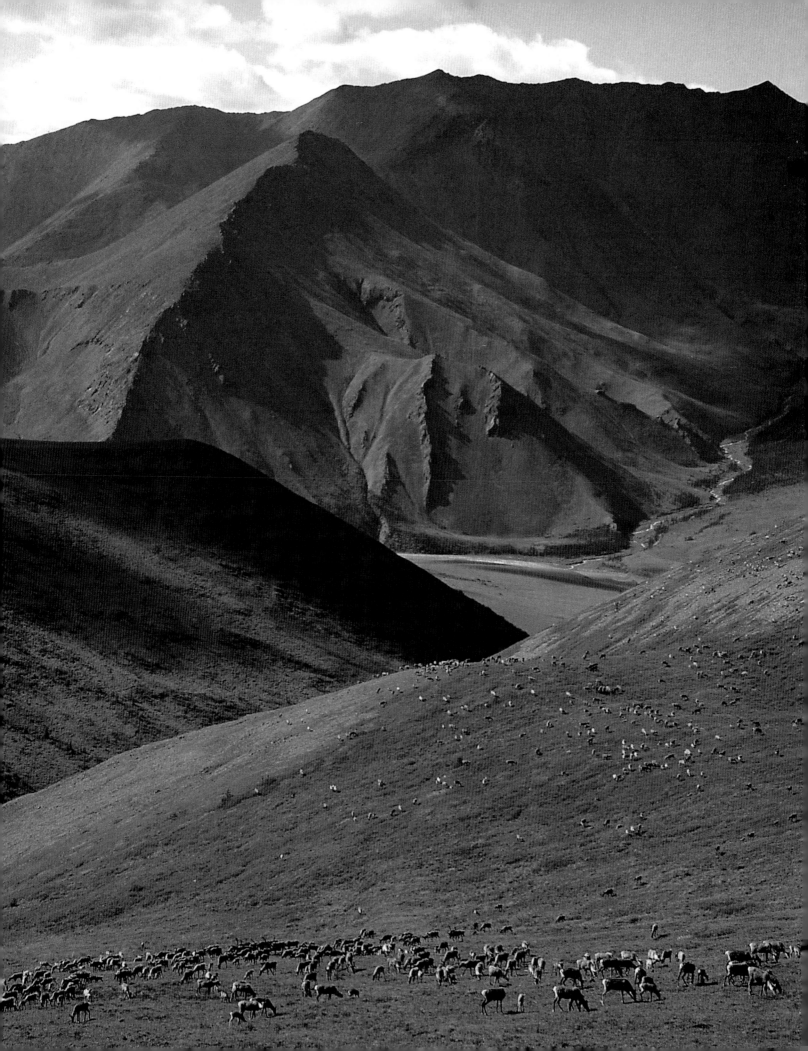

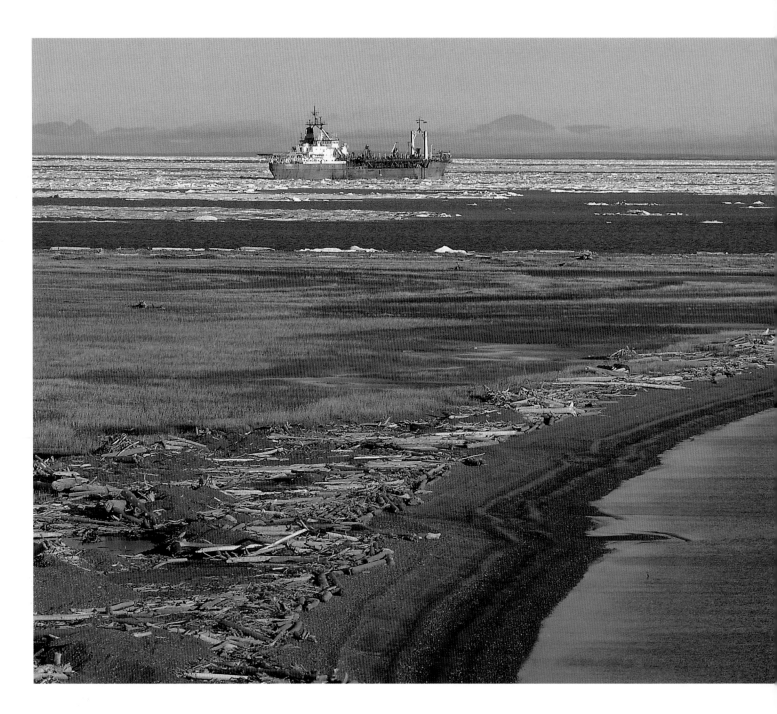

OIL EXPLORATION SHIP OFF
HERSCHEL ISLAND, BEAUFORT SEA

Tiny, isolated Herschel Island lies a few miles off the Yukon's northern shore. Except for the occasional oil exploration ship (above), it sees little outside traffic. At the turn of the century, some 1,500 American whalers were based here. A whaler's coffin (right, bottom) has been forced to the surface by permafrost. These rough-legged hawk chicks (right, top) are among the wide range of wildlife protected by Qikiqtaruk Territorial Park. The park exemplifies the environment and culture of the Inuvialuit of the Mackenzie Delta, who fish and hunt here.

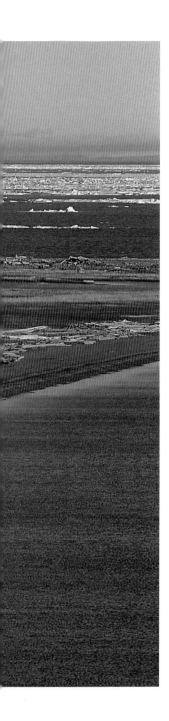

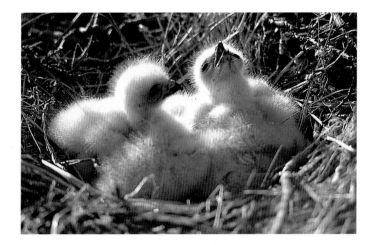

ROUGH-LEGGED HAWK CHICKS

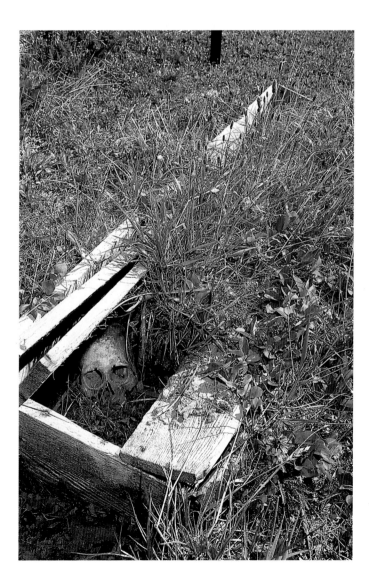

WHALER'S COFFIN ON HERSCHEL ISLAND

Old Crow (right), 120 miles north of the Arctic Circle, is the Yukon's most northerly settlement and the only community not serviced by roads. The Vuntut Gwich'in, whose name means "people of the lakes," have settled here between Crow Mountain and the Porcupine River because they depend on the annual caribou migration (below) for their survival. Their way of life dates back thousands of years. The Gwich'in use caribou meat and bone marrow for food, skins for clothing, bones for tools, sinews for twine and antlers for carving works of art. In late summer, they also reap a harvest from native plants such as cloudberries and blueberries (opposite).

ABOVE: BUILDING A LOG CABIN IN THE GWICH'IN VILLAGE OF OLD CROW

OPPOSITE: HARVESTING CLOUDBERRIES AND BLUEBERRIES

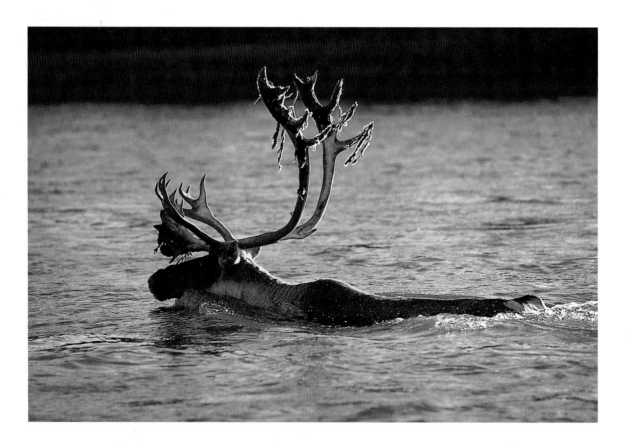

A CARIBOU SWIMS ACROSS THE PORCUPINE RIVER

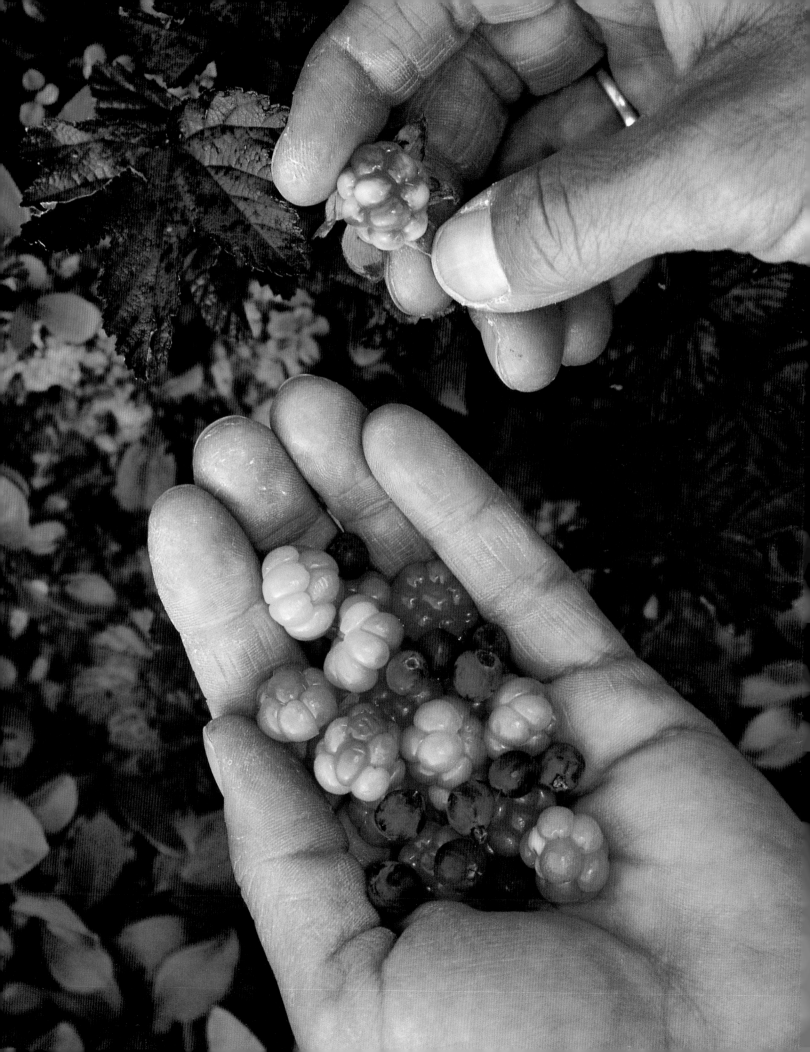

TUSSOCK OF GRASS IN FROZEN POND

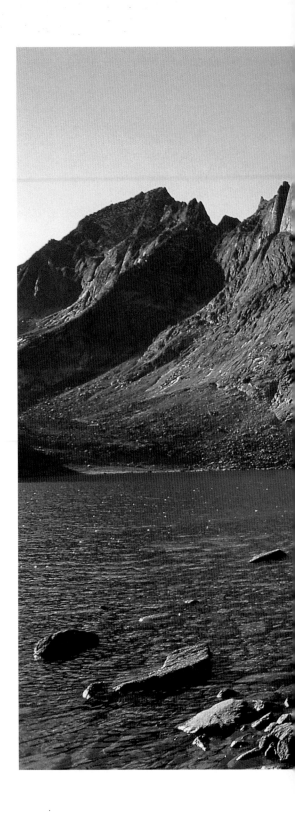

B earing a striking resemblance to
the granite spires of Patagonia,
the jagged backbone of the Tombstone
Range bursts out of the tundra in the
Ogilvie Mountains 9½ miles west of the
Dempster Highway at North Fork Pass.
The Tombstones are like a trademark
of the Yukon's wilderness: intrinsically
beautiful and rugged and home to ancient
cultures and wildlife. When hiking among
these spectacular spires (right), it is easy
to miss the beauty underfoot—a frozen
tussock of grass, for example (above).

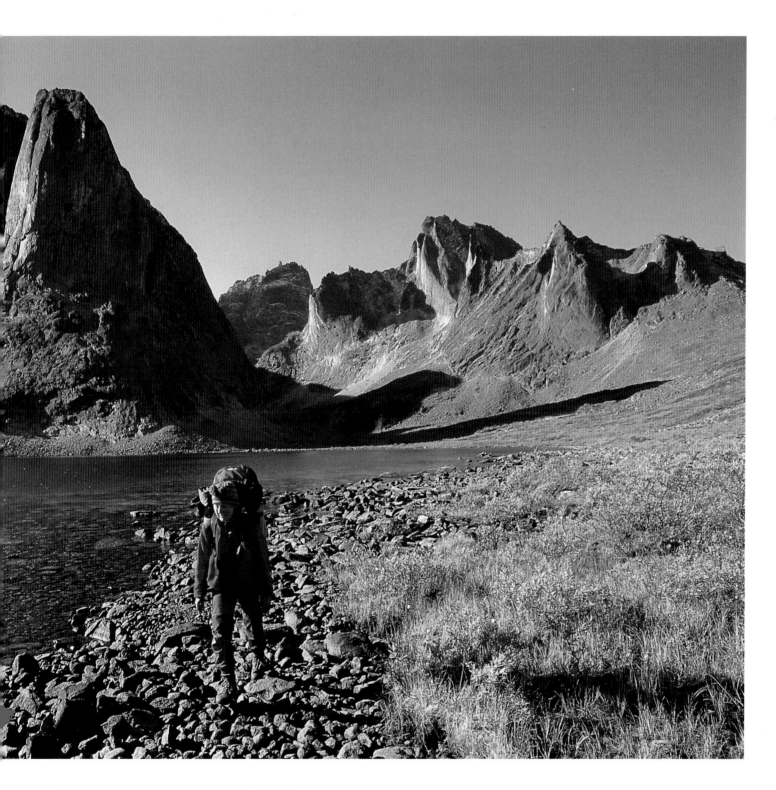

HIKING ALONG DIVIDE LAKE, WITH
MOUNT MONOLITH IN THE BACKGROUND

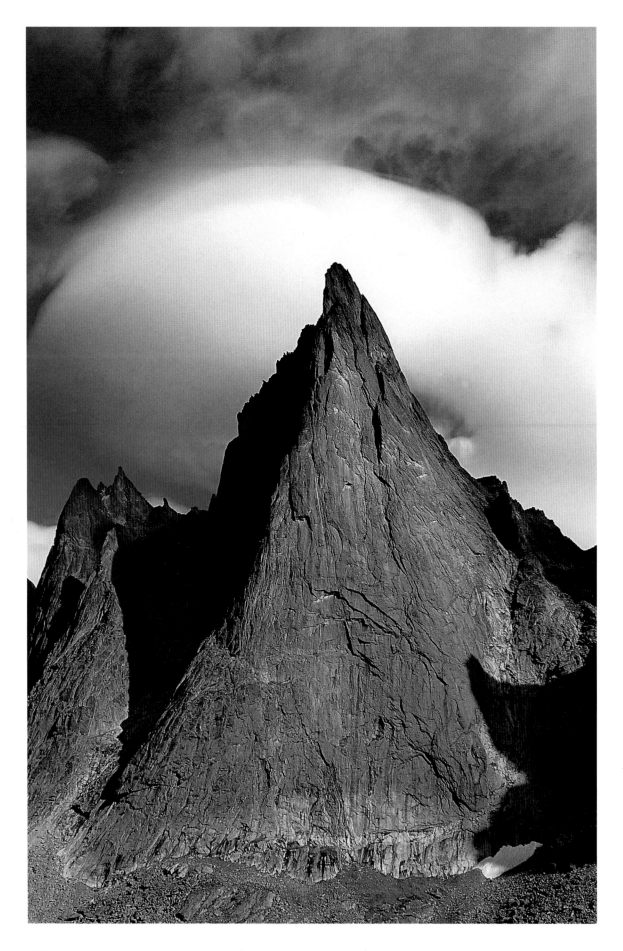

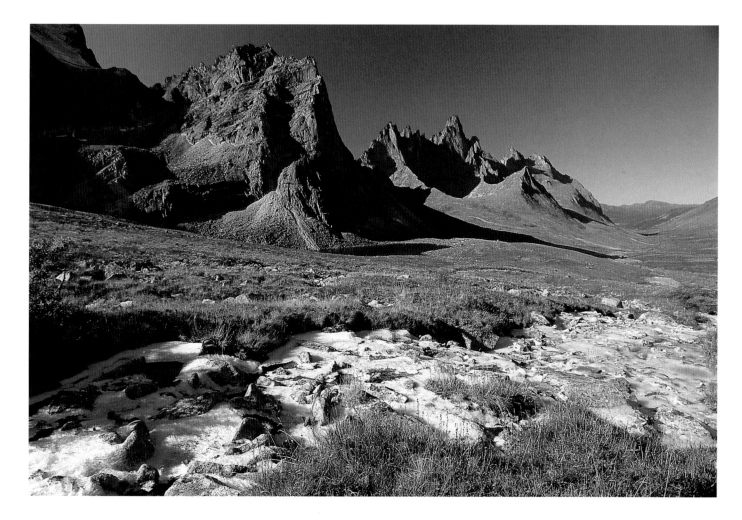

ABOVE: MOUNT TOMBSTONE IN THE MACKENZIE MOUNTAINS

LEFT: A PORTION OF MOUNT MONOLITH SEEN FROM TWIN LAKES

The Tombstones and the neighboring Blackstone Uplands lie within the Mackenzie Mountains ecoregion, the largest and most diverse natural tract in the territory. Located in a proposed territorial park, Mount Tombstone (above), the highest peak in the region, rises to a height of 7,192 feet (2,192 m). A part of Mount Monolith rises steeply above Twin Lakes (left).

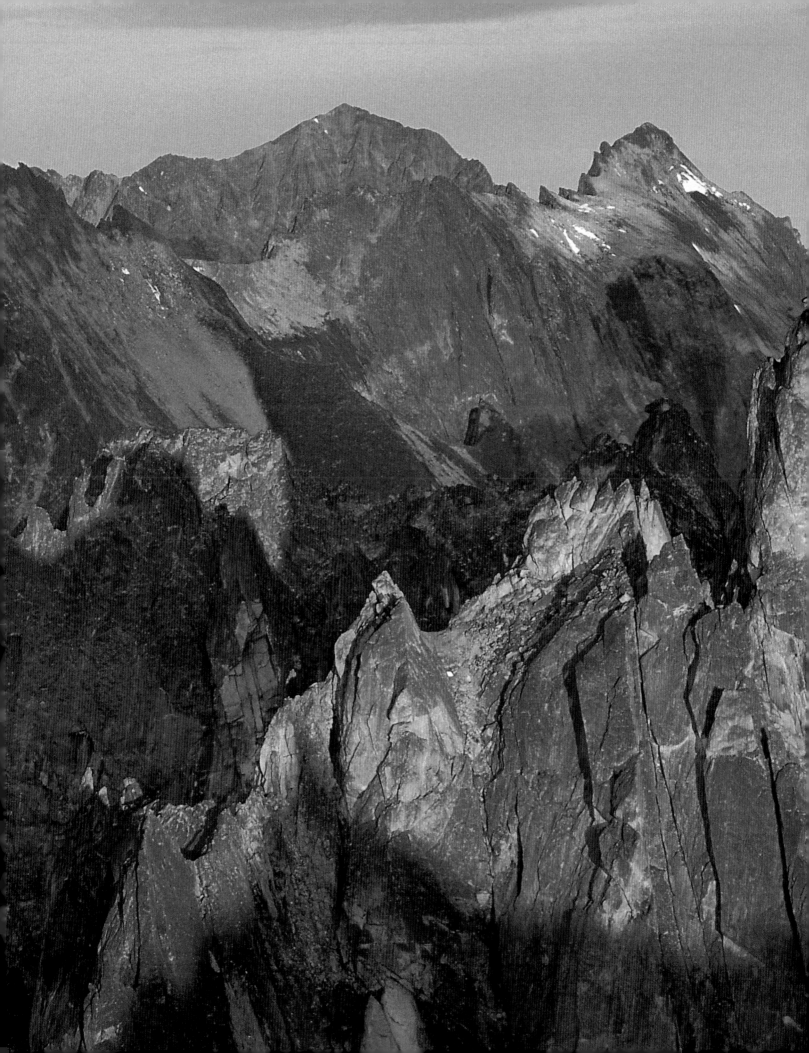

I t is easy to see why the local Han people call the area *Ddhah Ch'aa Ta*, "among the sharp, ragged rocky mountains." Although the craggy peaks (left) look inviting to climbers, serious alpine attempts have been thwarted by the inferior quality of the crumbly syenite rock. Unlike the sedimentary slopes of the northern Ogilvies and the Richardsons, the Tombstones are igneous intrusions that have been sculpted into stark monoliths of stone by wind, water and ice.

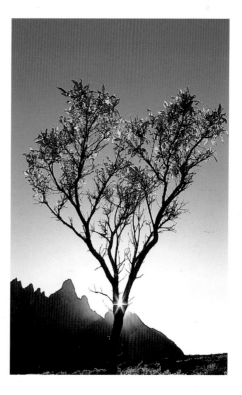

MOUNT TOMBSTONE
IN LATE SUMMER

For generations, the Han and Gwich'in followed their trading route between the Dawson area and the lower Peel River. In 1904, the North-West Mounted Police began winter patrols on dogsled between Dawson, Fort McPherson and Herschel Island, a 475-mile route that took them past Mount Tombstone (below). After the 1910 disaster of the Lost Patrol, all four members of which froze to death, native guides became a requisite part of winter patrols. The team is buried in the cemetery of St. Matthew's Anglican Church in Fort McPherson (right).

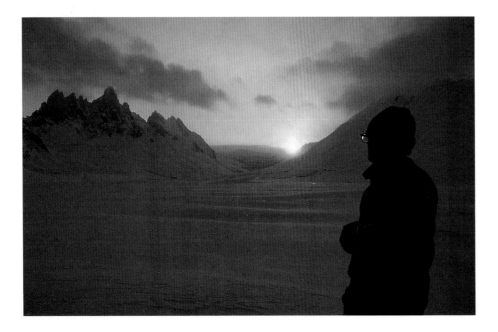

MOUNT TOMBSTONE AT MINUS 22 DEGREES F IN MARCH

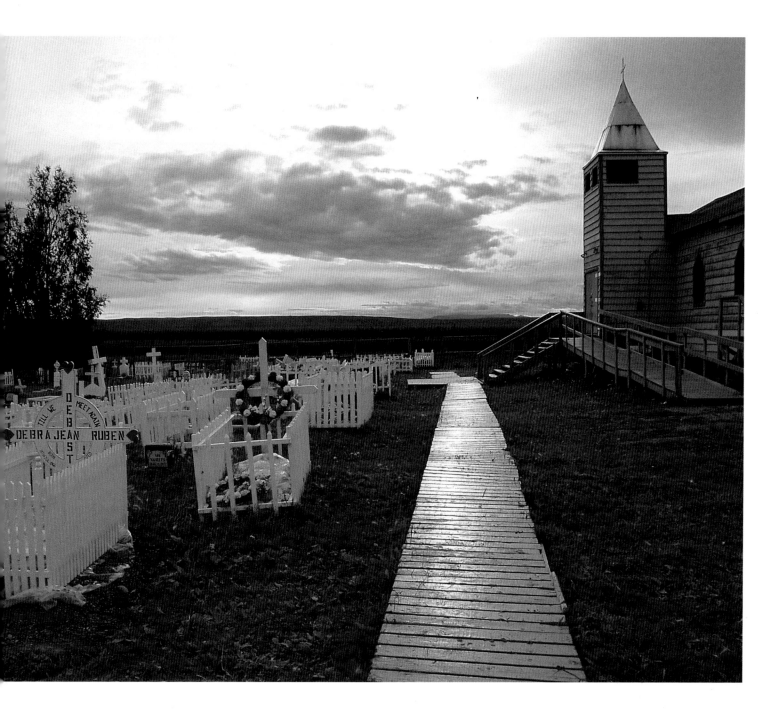

GRAVEYARD IN FORT MCPHERSON WHERE THE LOST PATROL IS BURIED

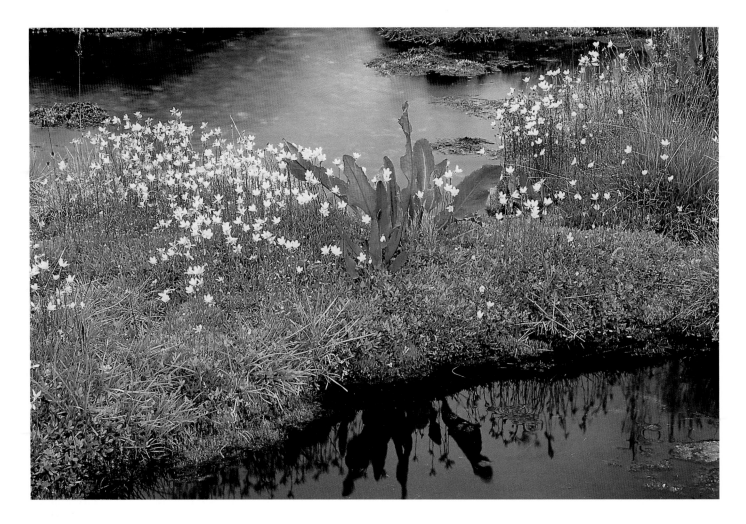

BOG SAXIFRAGE AND ARCTIC DOCK
BY THE SIDE OF THE DEMPSTER HIGHWAY

From the top of Sapper Hill, above Engineer Creek (right), it is easy to imagine what this northern land was like more than 100,000 years ago. Except for the changes brought about by the construction of the Dempster Highway, little has altered in the landscape. The short growing season and the presence of permafrost continue to ensure a rugged environment, yet the land blooms with a tenacious intensity in the summer, when the sun shines for almost 24 hours a day. Plants such as bog saxifrage and arctic dock (above) thrive in wet areas.

FOG CLOAKS THE DEMPSTER
HIGHWAY NEAR ENGINEER CREEK

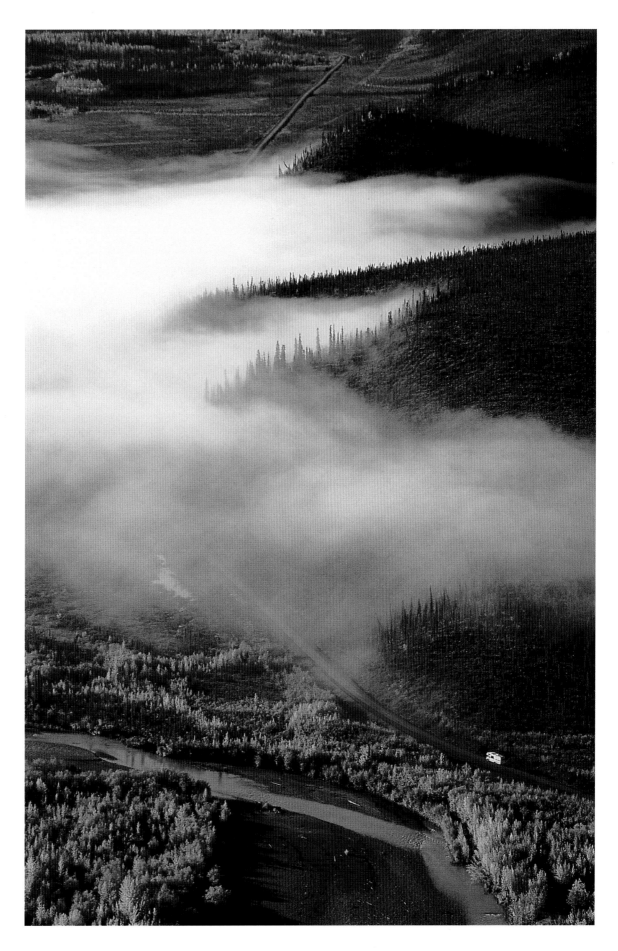

It's a birder's paradise along the Dempster Highway. The great diversity of habitats it traverses supports 159 species, 114 of them resident. Footprints of a shorebird that has been wading in mineral-rich Red Creek are imprinted on a rock (right, top). The rugged peaks above the Ogilvie River (below) are a paradise for raptors, including golden eagles and gyrfalcons, both predators of ptarmigan (right, bottom).

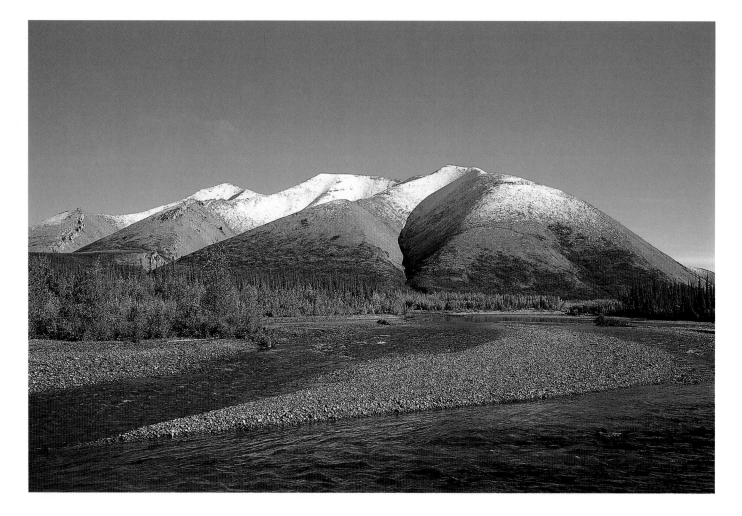

SNOW DUSTS THE RUGGED PEAKS OF THE OGILVIES

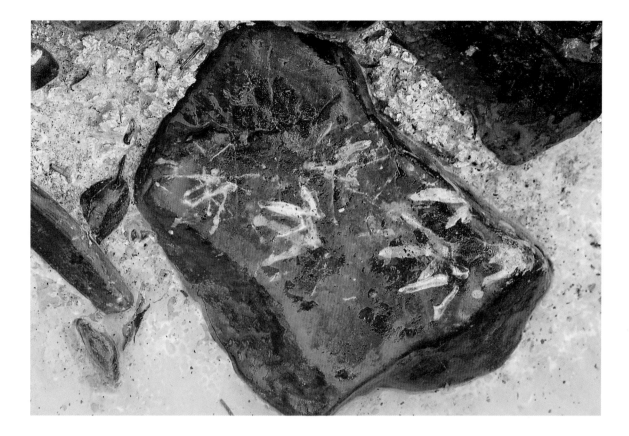

FOOTPRINTS OF A WATER BIRD THAT HAS BEEN
WADING IN RED CREEK

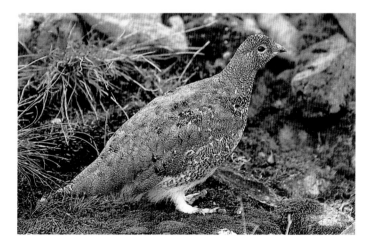

PTARMIGAN

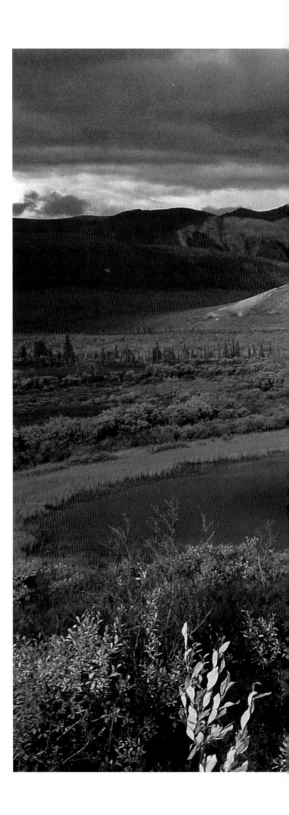

Hunting and trapping are still a way of life in the north; they depend on wildlife, which in turn depends on the preservation of natural habitat. When construction on the Dempster Highway was first begun in 1959, it created easy access to moose, the most important game animal in the Yukon. Overhunting soon resulted in a decrease in population, and in 1979, hunting was banned within five miles of the road. The moose population has since regenerated, and the animals can often be seen grazing on aquatic vegetation in the aptly named Two Moose Lake (below). Working for her big-game-outfitter father, Sarah Bolster (right) returns across the Blackstone Uplands from a foray into the Ogilvie Mountains.

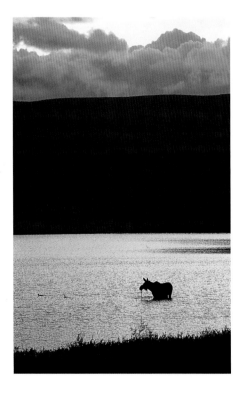

A MOOSE FEEDS IN A LAKE ON
THE BLACKSTONE UPLANDS

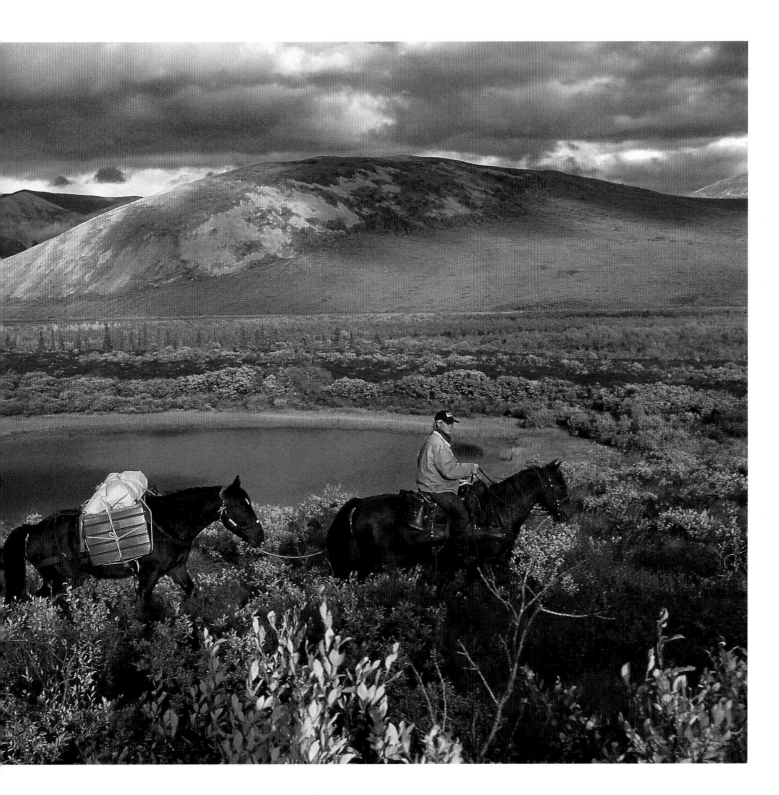

SARAH BOLSTER RETURNING HOME ACROSS
THE BLACKSTONE UPLANDS

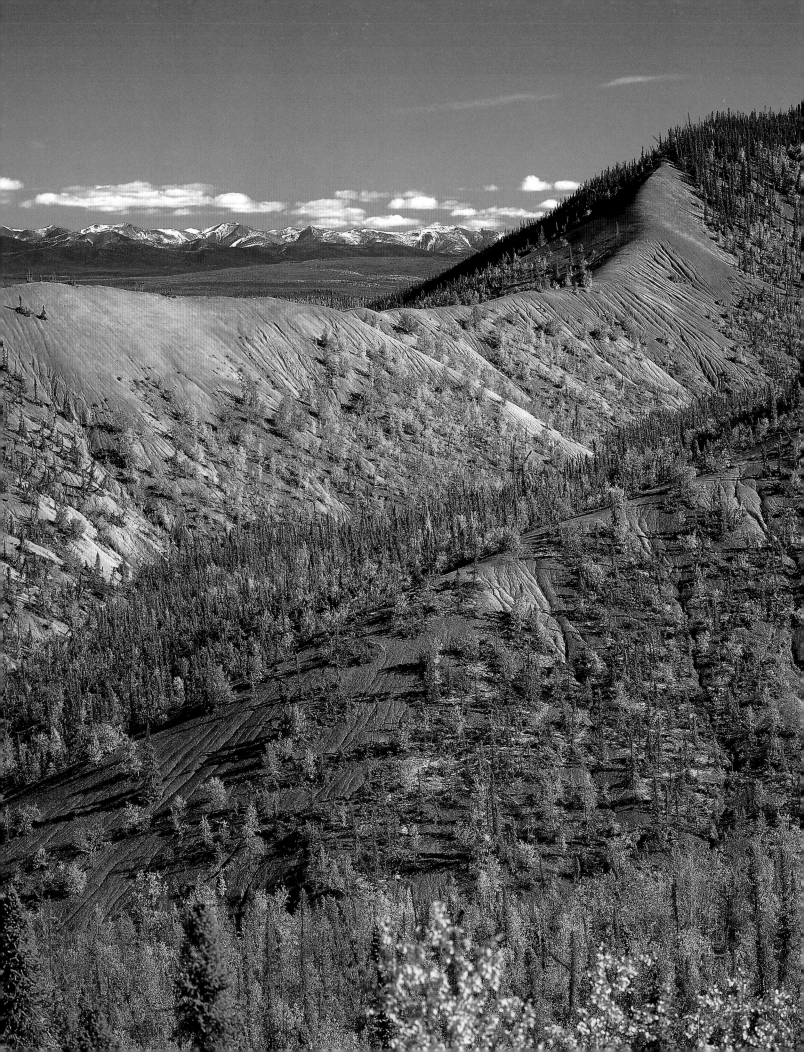

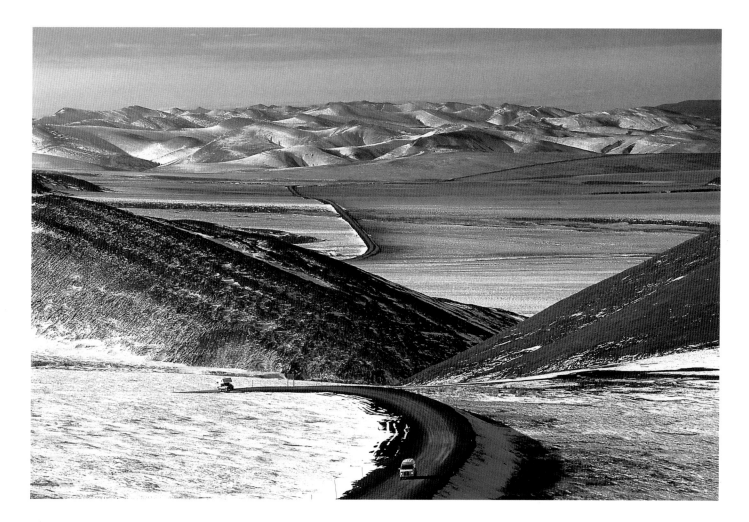

ABOVE: RICHARDSON MOUNTAINS FROM THE DEMPSTER HIGHWAY

LEFT: THE OGILVIE MOUNTAINS FROM EAGLE PLAIN

The Richardson Mountains, as seen from the Dempster Highway (above), are part of a unique region known as eastern Beringia. This alpine tundra environment has changed very little over the past 100,000 years. These rounded mountains and V-shaped valleys, unlike those elsewhere in the Yukon, have been worn down by weather rather than the sculpting forces of glacial ice. The absence of glaciation has allowed rare plants and relict species uncommon elsewhere in Canada to survive. The oil and gas found in the predominantly sandstone bedrock of Eagle Plain (left) prompted the building of the Dempster Highway.

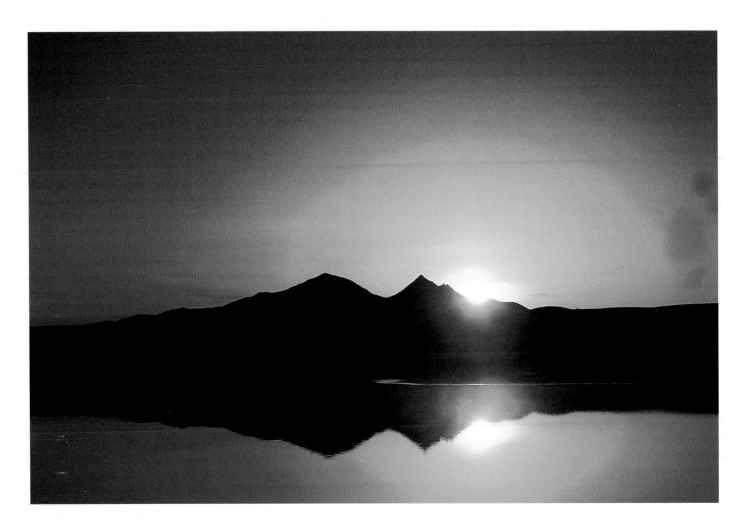

SUNRISE ON THE CENTRAL OGILVIE MOUNTAINS
FROM THE DEMPSTER HIGHWAY

DWARF WILLOW AND
BLUEBERRY BUSH IN AUTUMN

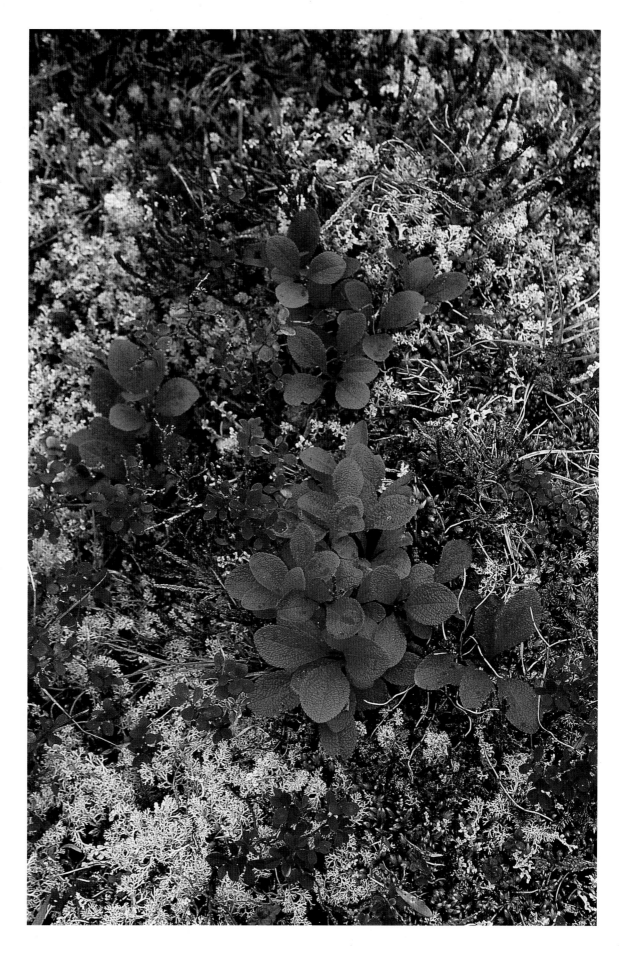

THE YUKON

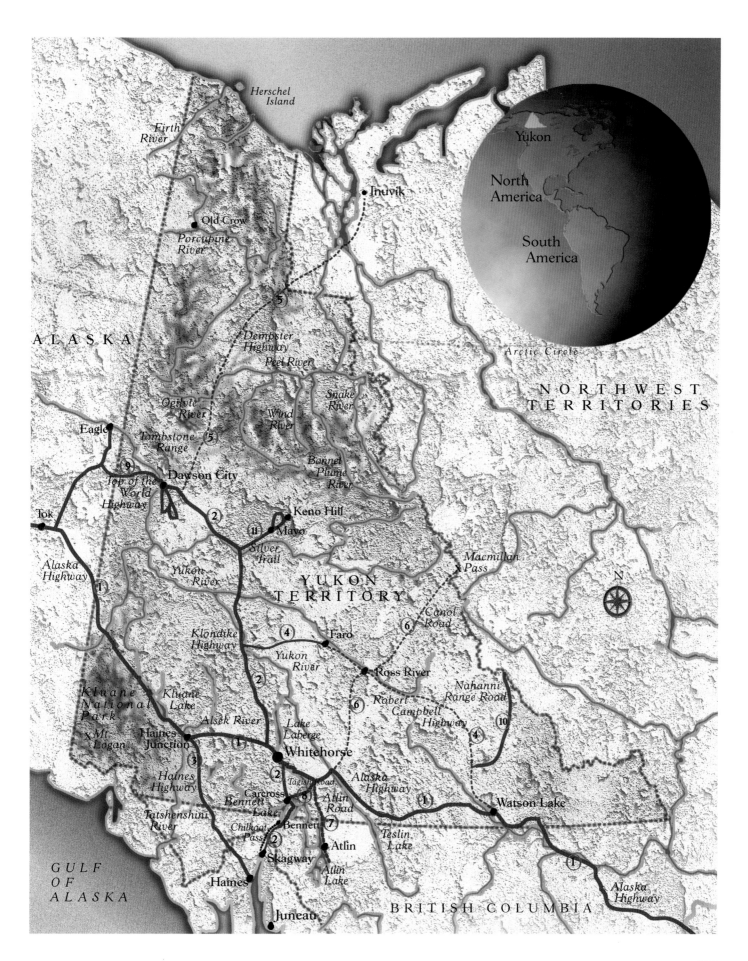

Herschel
Island

Firth
River

Inuvik

Yukon
North
America

South
America

Old Crow
Porcupine
River

ALASKA

Arctic Circle

NORTHWEST
TERRITORIES

Dempster
Highway
Peel River

⑤

Snake
River

Ogilvie
River

Wind
River

Eagle

Tombstone
Range
⑤

Bonnet
Plume
River

Top of the
World
Highway

⑨

Dawson City

Macmillan
Pass

Tok

②

Keno Hill
⑪ Mayo

Silver
Trail

Canol
Road

N

Alaska
Highway

①

Yukon
River

YUKON
TERRITORY

⑥

Klondike
Highway

④

Faro

⑥

②

Yukon
River

Ross River

Nahanni
Range Road

Kluane
National
Park

Kluane
Lake

Alsek River

⑥

Robert
Campbell
Highway

⑩

x Mt
Logan

Haines
Junction

①

Lake
Laberge

④

③

Whitehorse

②

Haines
Highway

Tagish Road

Alaska
Highway

Carcross
Bennett
Lake

⑥

Atlin
Road

Tatshenshini
River

Chilkoot
Pass

②

Bennett

⑦

①

Watson Lake

Atlin

Teslin
Lake

GULF
OF
ALASKA

Skagway

Atlin
Lake

Haines

BRITISH COLUMBIA

①

Alaska
Highway

Juneau

125

FURTHER INFORMATION

BOOKSTORE

Mac's Fireweed Books
203 Main Street
Whitehorse, YT Y1A 2B2
(403) 668-6104
Offers mail-order service.

BOOKS

These books and many more can be found in bookstores, gift shops and highway lodges throughout the Yukon.

Adney, Edwin Tappan. *The Klondike Stampede*. University of British Columbia Press, Vancouver, 1994.
Originally published in 1900 after Adney was dispatched to the Yukon in 1897 to write a first-hand account of the stampeders' experiences for *Harper's Weekly* and the *London Chronicle*.

Backhouse, Frances. *Women of the Klondike*. Whitecap Books, Vancouver, 1995.
The critical roles of the hundreds of women who hiked the trails with the men during the gold rush.

Berton, Laura. *I Married the Klondike*. McClelland & Stewart, Toronto, 1961.
A first-hand narrative of the times directly following the gold rush, written by the mother of Pierre Berton.

Berton, Pierre. *Klondike: The Last Great Gold Rush 1896-1899*. McClelland & Stewart, Toronto, 1972.
A historical account of the high jinks of the Klondike Gold Rush.

Black, Martha Louise. *Martha Black*. Alaska Northwest Books, Vancouver, 1989.
The autobiography of Martha Black, the Yukon's first woman Member of Parliament.

Cohen, Stan. *The Streets Were Paved With Gold: A Pictorial History of the Klondike Gold Rush 1896-99*. Pictorial Histories Publishing, Missoula, MT, 1977.

The Colourful Five Percent of the Yukon and Alaska. Annual publication. An illustrated guide to the Yukon's people.

Cruikshank, Julie, ed. *Life Lived Like a Story: Life Stories by Three Yukon Elders*. University of British Columbia Press, Vancouver, 1991.
Traditional stories by three Yukon elders.

Davignon, Ellen. *The Cinnamon Mine*. Studio North, Whitehorse, YT, 1988.
A humorous look at growing up along the Alaska Highway.

Josie, Edith. *Old Crow News: The Best of Edith Josie*. Whitehorse Star, Whitehorse, YT, 1964.
An intimate look at life in Old Crow.

Madsen, Ken. *Wild Rivers, Wild Lands*. Lost Moose Publishing, Whitehorse, YT, 1996.
Pictorial and verbal insights into the value of wilderness in the north.

McClellan, Catharine. *Part of the Land, Part of the Water: A History of the Yukon Indians*. Douglas & McIntyre, Vancouver, 1987.

Neufeld, David and Frank Norris. *Chilkoot Trail: Heritage Route to the Klondike*. Lost Moose Publishing, Whitehorse, YT, 1996.
A Yukoner and an Alaskan describe life on the trail before, during and after the gold rush.

North, Dick. *The Lost Patrol: The Mounties' Yukon Tragedy*. Raincoast Books, Vancouver, 1995.
The true story of four North-West Mounted Police officers who died during a brutal cold snap on their way from Fort McPherson to Dawson City in 1910.

Rock and Roll Moose Meat Collective. *The Original Lost Whole Moose Catalogue: A Yukon Way of Knowledge*. Lost Moose Publishing, Whitehorse, YT, 1992.
What life is really like in Canada's Yukon.

Simpson, Jimmy. *A Vanishing Breed: The Gold Miner*. Simpson Publishing, Chapmansboro, TN, 1996.
A gold miner's diary.

Steele, Peter. *Atlin's Gold*. Caitlin Press, Prince George, BC, 1995.
The shared adventure of a family living part-time in the idyllic town of Atlin, British Columbia, near the Yukon border.

Wright, Allen A. *Prelude to Bonanza: The Discovery and Exploration of the Yukon*. Gray's Publishing, Sidney, BC, 1976.
The colorful events and the individuals who loved the great north.

CD-ROM

Klondike Gold. Hyperborean Group, Whitehorse, YT.
Includes hundreds of historic photographs and a rare interview with Robert Service.

VIDEOS

The Gold Rush Trail. Logan Video Services, Whitehorse, YT.

Journey Back to the Wild: 100 Years of Robert Service. Alaska Commemorative Ventures, Juneau, AK.